IMAGES
of America

RURAL LIFE
IN THE LOWCOUNTRY
OF SOUTH CAROLINA

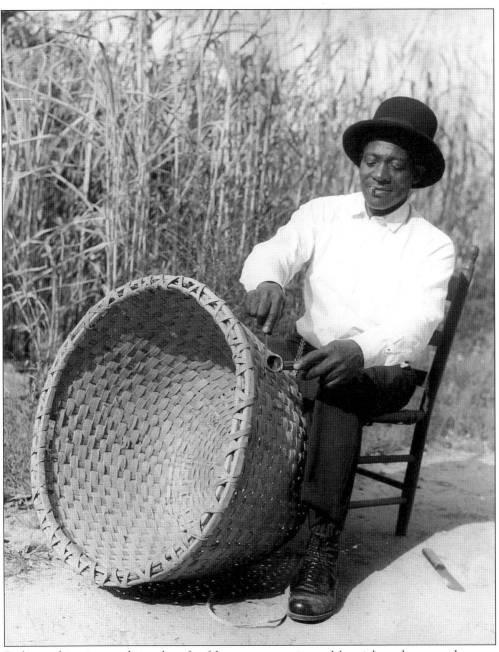

Basket making is a traditional craft of Lowcountry artisans. Materials such as wood, straw, bamboo, and pine needles are often used. The finished product may be utilitarian or aesthetic, depending on the skill and predilections of the maker. Pictured is Isaac Scott.

IMAGES
of America

RURAL LIFE
IN THE LOWCOUNTRY
OF SOUTH CAROLINA

Dennis S. Taylor
Clemson University Libraries

ARCADIA

Published by Arcadia Publishing,
an imprint of Tempus Publishing, Inc.
2 Cumberland Street
Charleston, SC 29401

Printed in Great Britain.

Library of Congress Catalog Card Number: 2002103965

For all general information contact Arcadia Publishing at:
Telephone 843-853-2070
Fax 843-853-0044
E-Mail sales@arcadiapublishing.com

For customer service and orders:
Toll-Free 1-888-313-2665

Visit us on the internet at http://www.arcadiapublishing.com

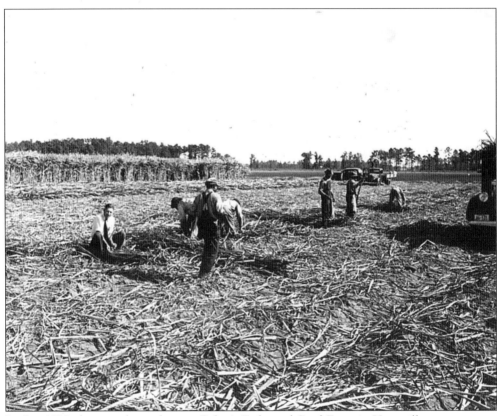

In this 1939 photograph, workers at Coker's Pedigreed Seed Farm in Hartsville prepare sugar cane for delivery to County agents for seeding.

CONTENTS

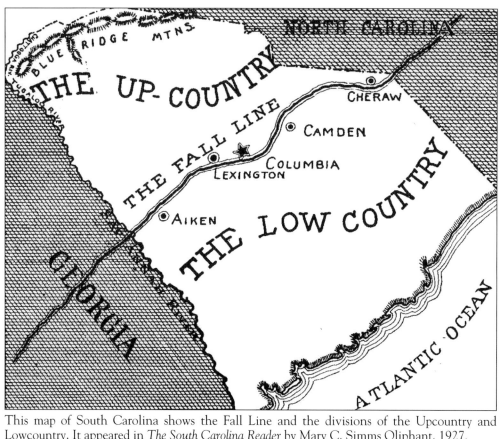

This map of South Carolina shows the Fall Line and the divisions of the Upcountry and Lowcountry. It appeared in *The South Carolina Reader* by Mary C. Simms Oliphant, 1927.

ACKNOWLEDGMENTS

I wish to thank Laura E. Daniels, acquisitions editor at Arcadia Publishing, for her assistance in making this book possible.

INTRODUCTION

Let me begin my introduction with a brief description of the Lowcountry. Where is it?

In the 1930s, Charleston writer Herbert Ravenel Sass wrote that the Lowcountry "lies close to the sea, but only a part of it has the salt flavor of the sea . . . it belongs to the forest rather than to the ocean." Historians Mary C. Simms Oliphant and A.V. Huff defined the Lowcountry as the geographic area south and east of the Fall Line. The Fall Line is a low, east-facing cliff that parallels the Atlantic coastline from New Jersey to the Carolinas. It separates the metamorphic rocks of Appalachia from the sedimentary rocks of the Coastal Plain. In South Carolina, the Fall Line runs from Aiken through Columbia and northeast to Cheraw. Towns and cities developed along this line because waterpower was available to drive machinery and milling equipment. The Lowcountry, therefore, encompasses almost twenty-seven counties, or approximately two-thirds of the state.

Agriculture has played a starring role in this area from the beginning. From rice cultivation along the coast to cotton growing inland, the Lowcountry and agriculture have been partners throughout history. For years, rice, cotton, and tobacco dominated the economy, but, as electricity and modern farming methods altered longstanding agricultural practices, potatoes, tomatoes, watermelons, and poultry growing challenged the original troika. Through the years, many photographs have been taken that depict the prominence of agriculture and its evolution.

Photographs, however, cannot tell the whole story. The photos cannot convey the farmers' frustration when weather did not cooperate, the crops failed, and food was scarce. Nor do they convey the backbreaking labor required to make a farm prosper. The images only superficially describe the system of racial segregation that promoted unequal opportunities for whites and African-Americans, and religious faith—a force that shaped the region even more than agriculture—is depicted only obliquely. Of course, the photographers cannot be faulted for these shortcomings. Their mission was to document the activities of the Cooperative Extension Service, and this they did very well.

The intent of the photographers is apparent in most of the photographs. Sometimes a process was captured, or, at other times, an individual who set a record growing livestock. In either instance, I have written captions to provide adequate identification and, if necessary, minimal interpretation. I will have succeeded if these images, along with my words, whet the reader's appetite for more information on specific topics. If so, I recommend the following sources: Augustine Smythe's *The South Carolina Lowcountry*, 1932; Mary C. Simms Oliphant's *History of South Carolina*, 1964; Ernest Lander's *South Carolina an Illustrated History of the Palmetto State*,

1988; A.V. Huff's *History of South Carolina in the Building of the Nation*, 1991; and Walter C. Edgar's *South Carolina, a History*, 1998. Historical information can also be obtained via County websites on the World Wide Web. Of course, nothing would substitute for a field trip to some of the locales!

Finally, my introduction would not be complete without paying homage to L.W. "Lew" Riley, the principal photographer of these images, and others who worked for the Clemson Extension Service. These include J.D. Brown, J.K. Eargle, E.C. Hunton, Stan Lewis, J.A. Smith, and Jack Trimmier. The photographs presented here, as well as those in my earlier volume, *Rural Life in the Piedmont of South Carolina*, were drawn from a collection of 12,000 images from the Clemson University Libraries. They await further discovery and enjoyment.

D.S.T.
April 2002

One
THE LAND

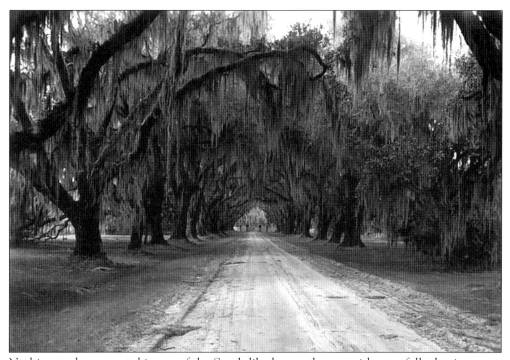

Nothing evokes a mental image of the South like huge oak trees with gracefully draping moss. Pictured above is Tomotley Plantation avenue in Beaufort. Tomotley, a name derived from the Yamassee Indians, means "hewed timber town."

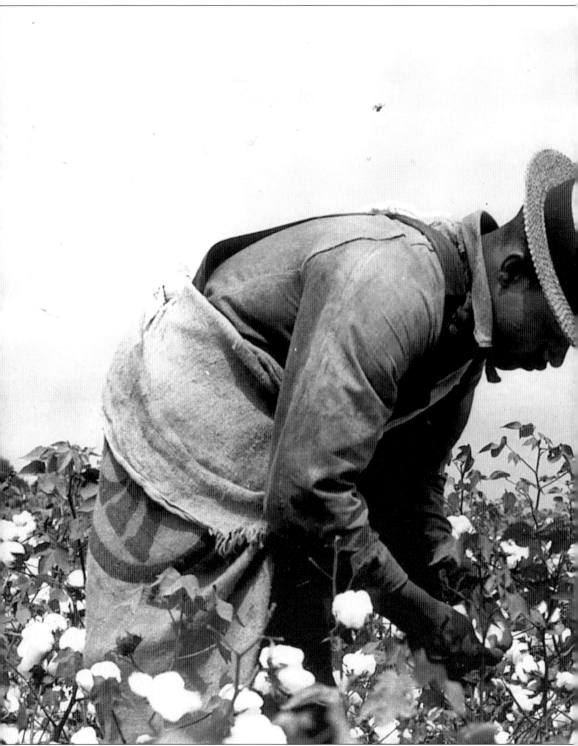

Cotton growing has played an important role in the history of South Carolina. Because of new mechanical processes, the state became prominent in the textile industry during the 20th

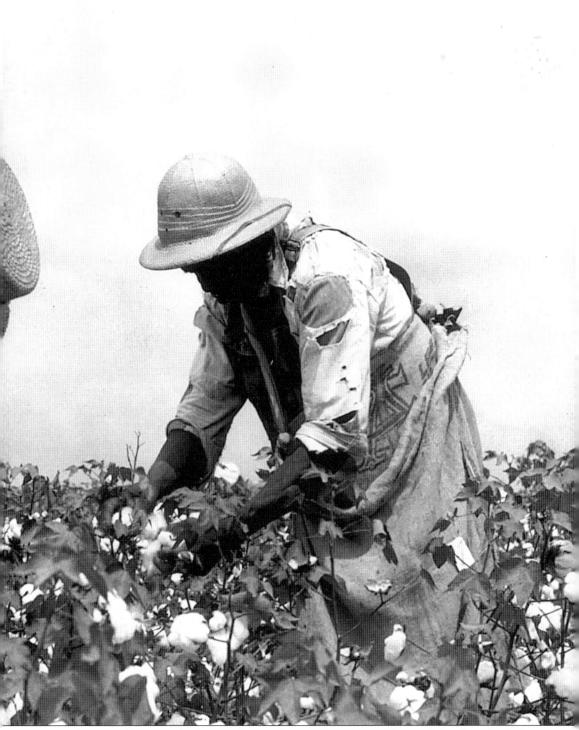

century, but not all farms relied on modern pickers and combines. The traditional method of cotton production relied on backbreaking labor. This picture was made in 1943.

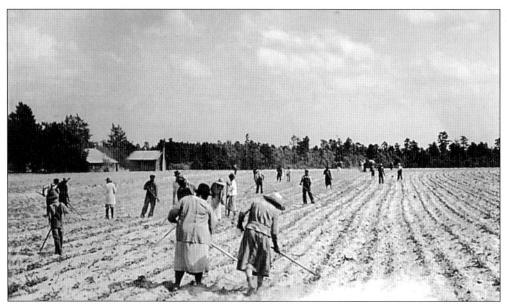

This photograph, taken in Lexington in 1938, is a scene from the old South—field hands chopping cotton. Until the days of mechanical pickers and cultivators, all work was done by hand.

The Extension Service encouraged cotton farmers to increase their yields by rewarding those who could produce the most cotton on five acres. The woman pictured above is Mrs. C.H. Mathis and her overseer A.B. Hightower of Blackville.

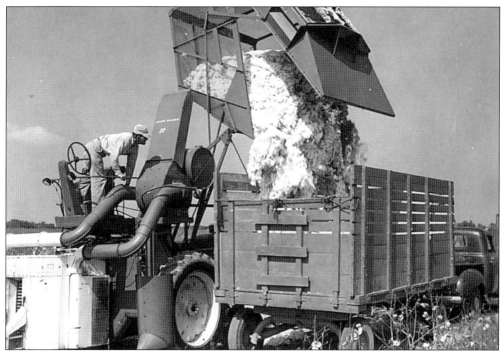

Cotton growing was transformed by technology in the mid-20th century. With the use of pickers, combines, gins, and chemical fertilizers, cotton yields increased dramatically, establishing South Carolina's leadership in the production of textiles. This picker is unloading cotton grown in Calhoun County.

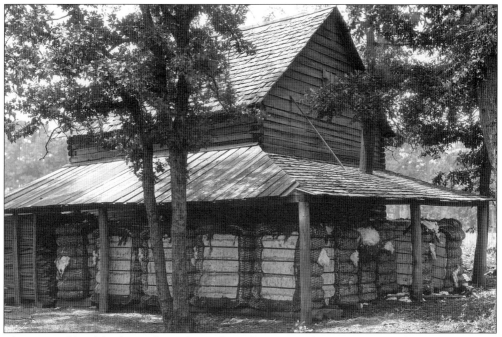

This venerable old tobacco barn, located on the Rogers farm in Marion, doubled as storage place for cotton.

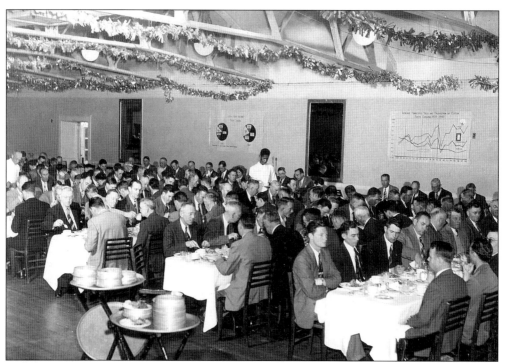

Each year, cotton growers assembled in Columbia to reward growers. This picture was taken at the Cotton Growers Banquet at the Jefferson Hotel, *c*. 1948.

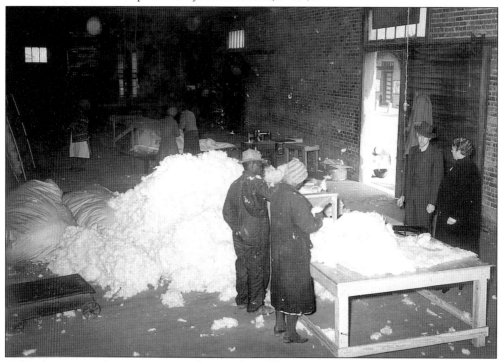

A local mattress factory is pictured in Bishopville in 1941; the freshly delivered cotton awaits processing.

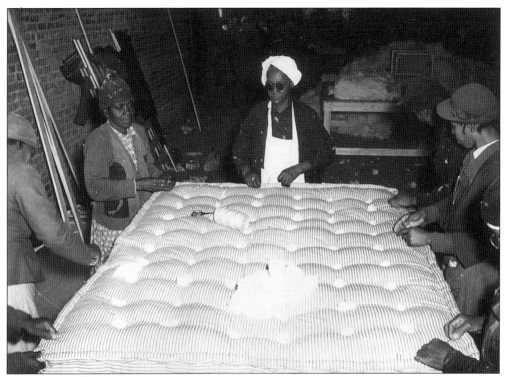

This photo of the mattress factory in Bishopville shows the hand stitching of the ticking.

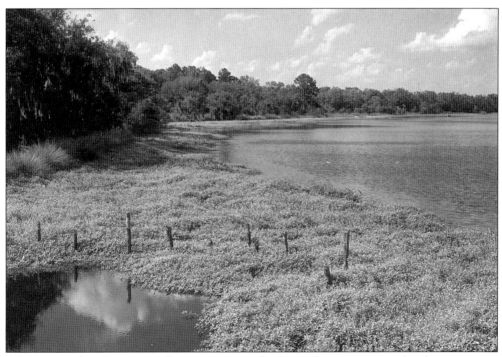

Alligator weed, or "gator grass," was once grown for forage, but is now considered an aggressive weed. Here, it blankets the surface of a pond once used for rice growing in Colleton County.

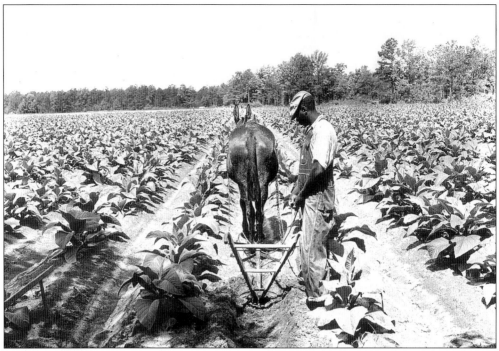

This Florence farmer is using a mule to run a 10-inch "middle buster" for cultivation of tobacco. The implement could be used for digging and to open furrows and trenches.

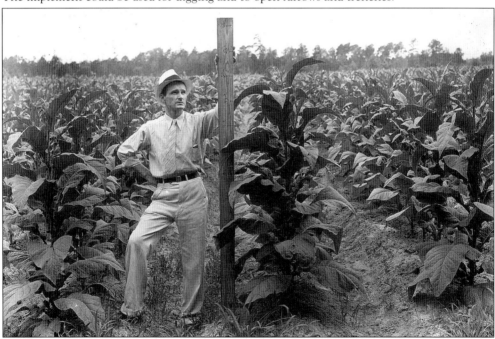

Most tobacco plants average four to five feet high, but this one in Harleyville reached a height of over five feet. For the highest yield of the best quality flue cured tobacco, growers would strive to grow a big plant that became nitrogen deficient near maturity, a process that required sandy, coastal soil.

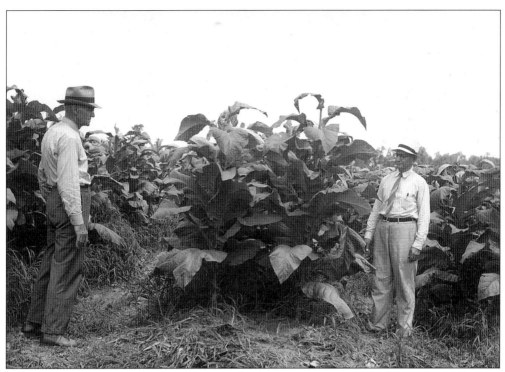

This is a tobacco growing practice known as double-row cultivation, which is two rows of plants grown on a single row. Double-row cultivation yielded more tobacco per acre.

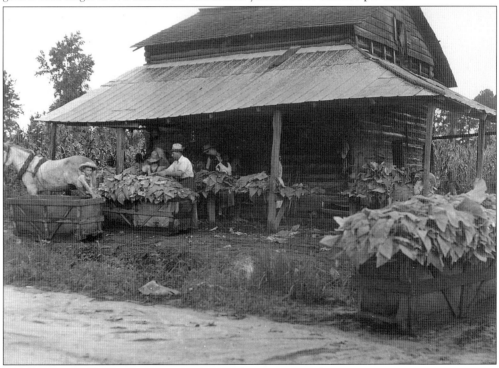

This 1939 scene from Horry County shows tobacco arriving for curing.

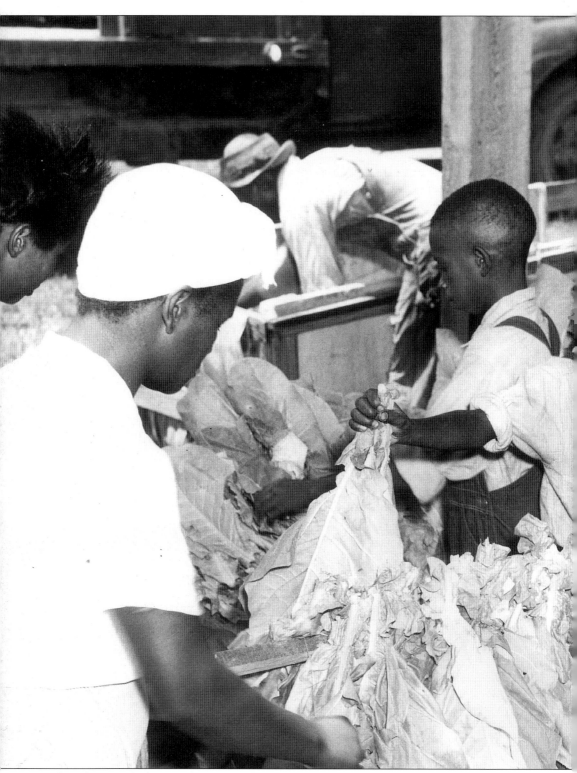

This photograph depicts the process known as "stringing tobacco." The following pictures

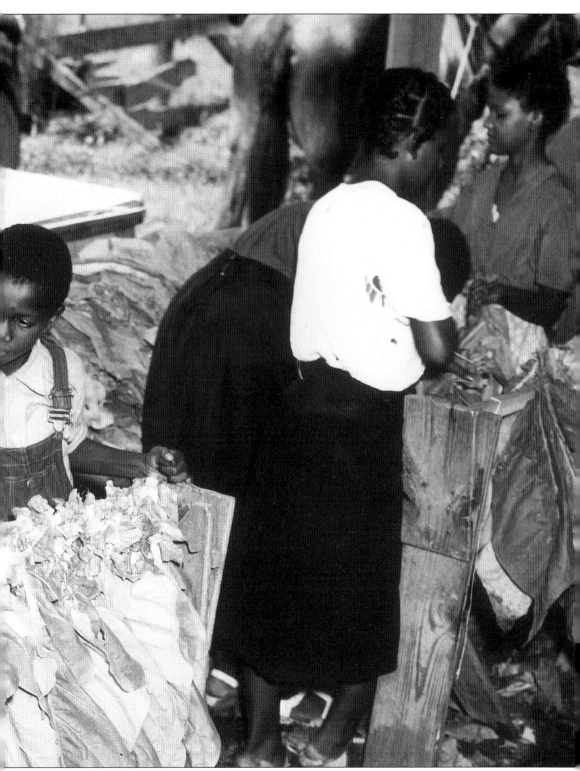

provide an explanation of the entire process.

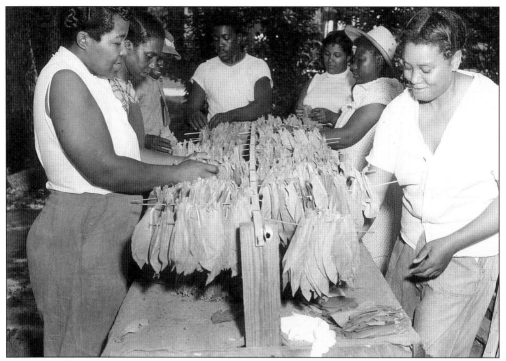

Stringing tobacco involved threading wilted leaves called "hands" onto a string or piece of twine. Using a needle, the stem was pierced near the base of the leaf and the string was pulled through the hole. The "hands" were then tied to sticks that were suspended in a barn to cure. The spacing of the leaves on the string varied according to the kind of tobacco and curing process. About 30 hands, or 90 leaves, could be tied to a stick.

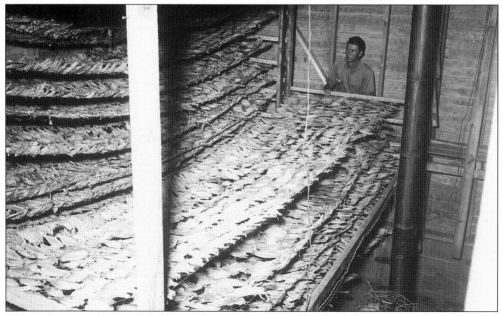

If the tobacco curing involved heat, the term "flue cured" was used because smoke was vented to the outside through a flue. The location and date of this curing barn are unknown.

Once the tobacco was cured, it went to market. This tobacco market operated in Darlington in 1941.

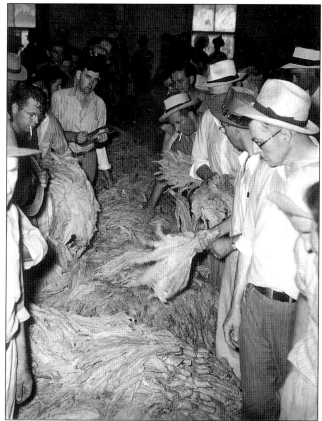

Tobacco, an important Lowcountry crop, had to be cured in structures like these before it went to market. These tobacco barns, under construction in 1939, were located in the town of Cope in Orangeburg County.

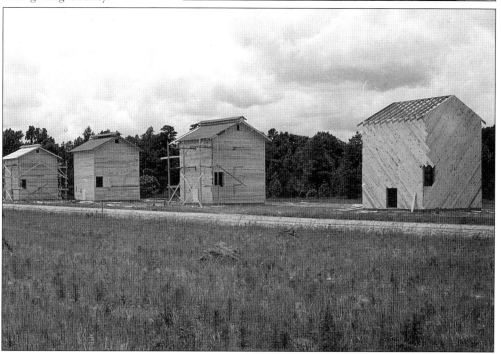

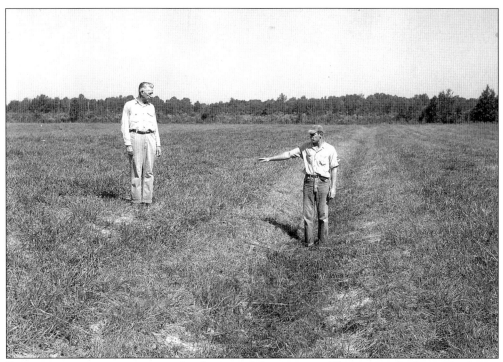

Drainage systems are a necessity for the coastal Lowcountry. This v-type ditch in Charleston was used to drain pastureland. Because much land is near or at sea level, proper drainage is crucial to growing crops

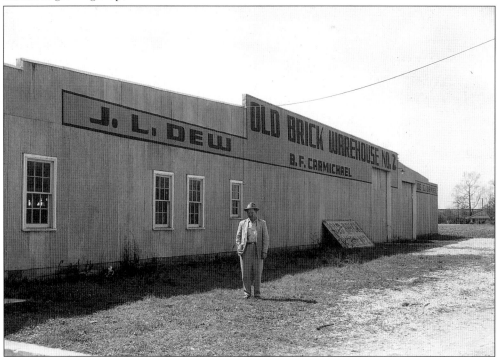

This tobacco warehouse in Mullins was a hub of activity in the 1950s.

Coastal Bermuda grass is a tenacious warm-season grass that grows well in less than fertile soils. It is used to control erosion and for forage.

Crab grass—the bane of the farmer—could overtake gardens and lawns in a short time. A rotary hoe was used effectively to combat it, but the seedlings here are too large to be killed that way.

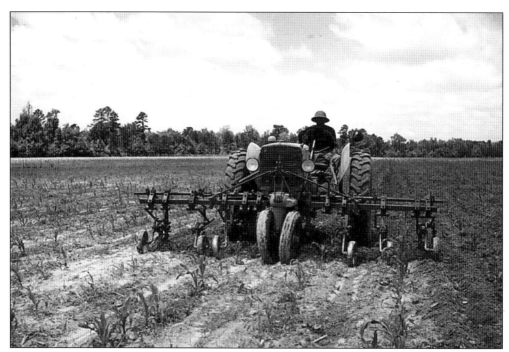

On a field of corn at the Rast farm in Cameron (Calhoun County), this cultivator worked four rows simultaneously. One farmer, therefore, could save considerable time and money. The year is 1949.

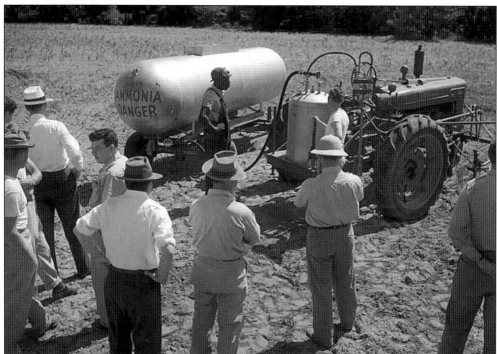

Without chemical fertilizers to boost agricultural yields, farmers succumbed to the vagaries of nature. Here, liquid nitrogen fertilizer is being transferred to a tractor for distribution.

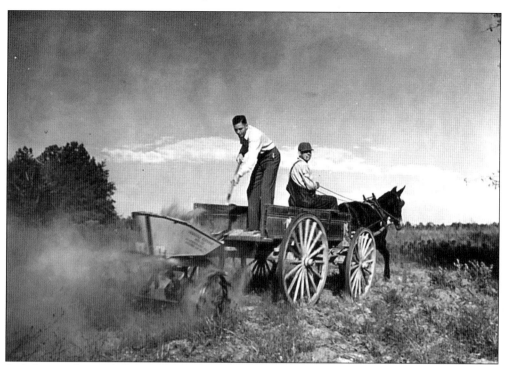

Soil frequently needed the addition of lime to "sweeten" it, or make it more conducive to growing plants. This lime is being spread by hand in Jasper County.

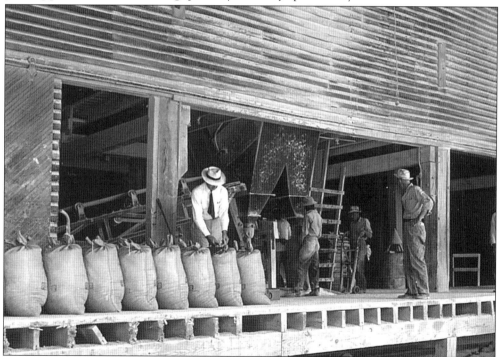

To verify the chemical content of fertilizers, they were inspected and tagged before they were sold. This fertilizer inspection took place at Cayce in 1949.

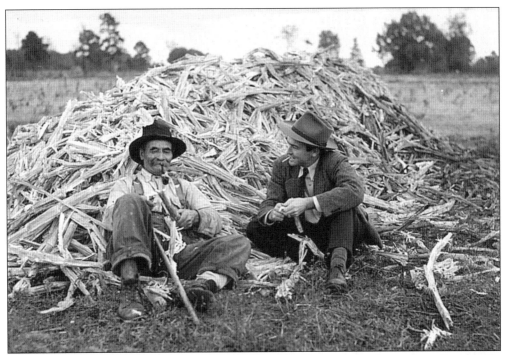

County agent T.O. Bowen and an unidentified farmer in Sumter relax from a day of hard work. County agents enjoyed close relationships with farmers and visited the farms at least once a month to monitor farming progress.

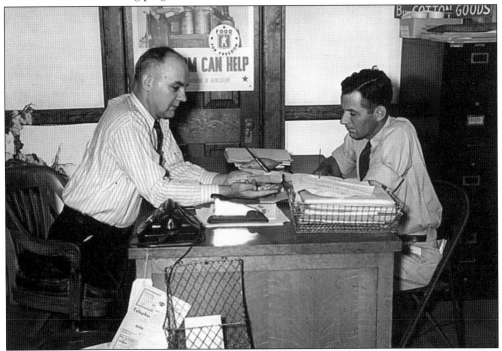

Sumter County agent J.M. Eleazar is pictured here with a farmer. County Extensions Offices disseminated accurate and up-to-date farming information.

The Coastal Experiment Station held fertilizer meetings to inform farmers of the latest developments in fertilizer manufacturing and application.

The Extension Service conducted a rice cultivation demonstration in Colleton County in the early 1950s.

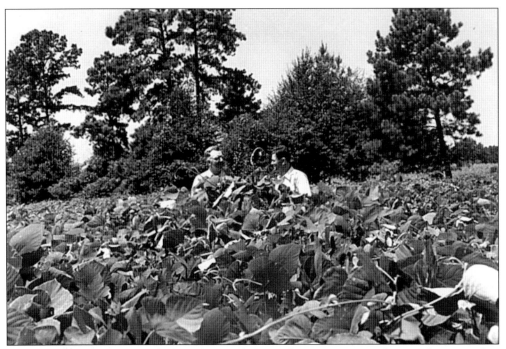

To some, kudzu is the "vine that ate the South." To others, it is a "miracle vine" because it has a high nutritive content. Here in Cameron, a county agent, O.W. Cain, and a farm owner, H.M. Perrow, wade through a field of chest-high kudzu that was used for feed and silage.

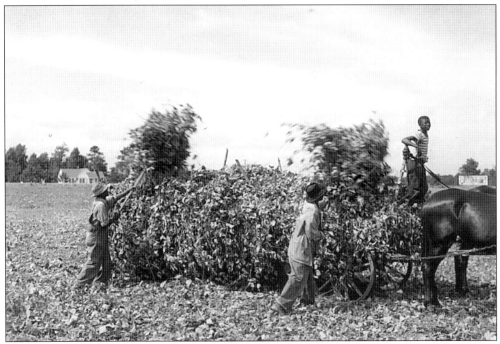

Here in Lexington County, kudzu was used for hay. The United States Department of Agriculture (USDA) listed kudzu as a "common weed" in 1970 even though they advocated it to control erosion. By 1997, kudzu was classed a "noxious weed."

The haystack is supported by a frame such as this one.

Hay is grown statewide and nothing bespeaks bucolic life more than haystacks. This picture was made in Berkeley County.

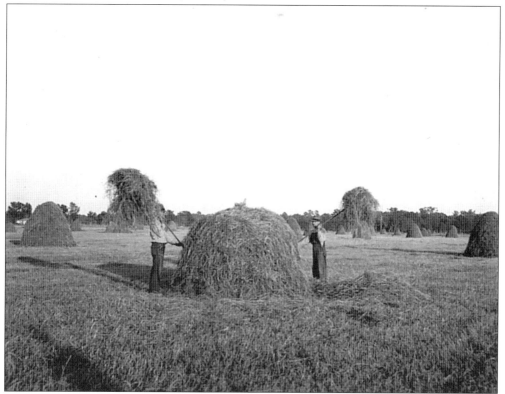

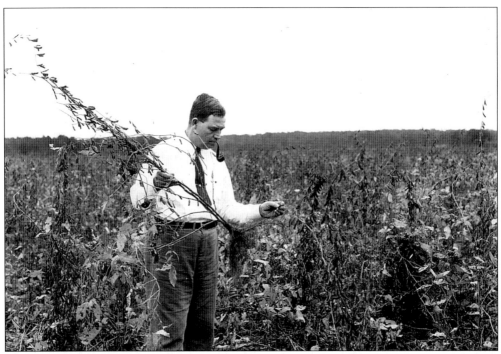

Soybeans have become a principal agricultural crop in South Carolina since this photo was made in 1939. This soybean field was sown at the rate of 10 pounds of seed per acre with a yield of 25 bushels of soybeans per acre.

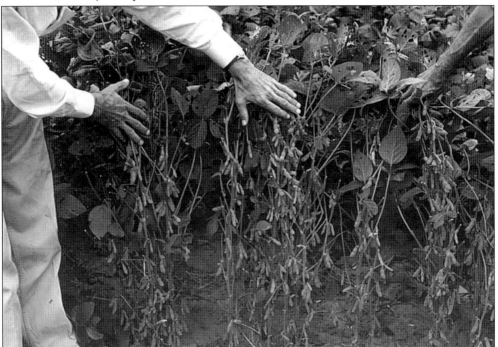

This close-up allows a clear view of the growth habits of soybeans. After the hulls are removed, the tiny beans may be pressed for oil, or used for other purposes.

Benne, also called sesame, grew on some farms because the seeds yielded high-quality oil. Today, they are better known for their use in the delectable confectionery treat "benne wafers." This field was in Orangeburg, 1955.

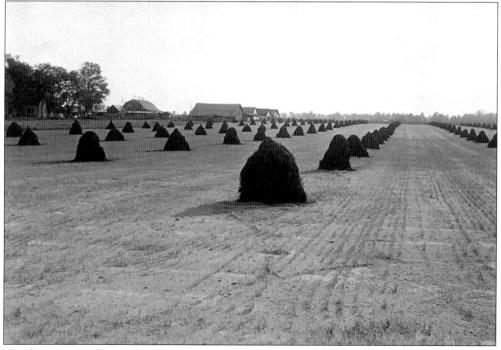

No, these are not haystacks. They are stacks of peanuts ready for pickup in Sumter County.

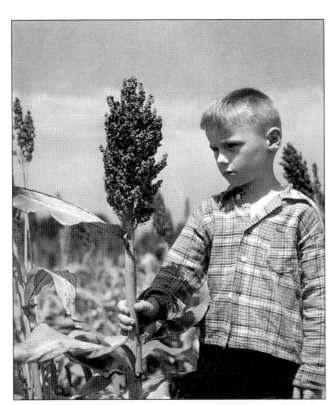

This distinctive plant is milo, also called sorghum. It was grown on the John Culler farm in Orangeburg.

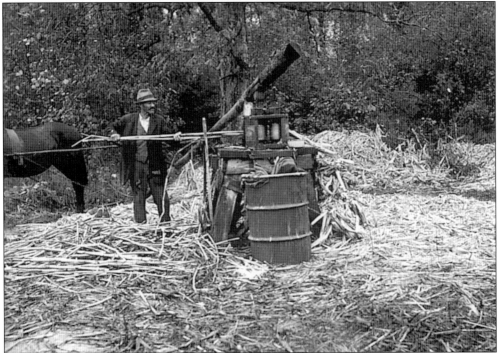

The process of syrup making involves several steps. First, sorghum was cut and taken to a press to extract the juice. This Johnsonville farmer used mule power to press out the juice.

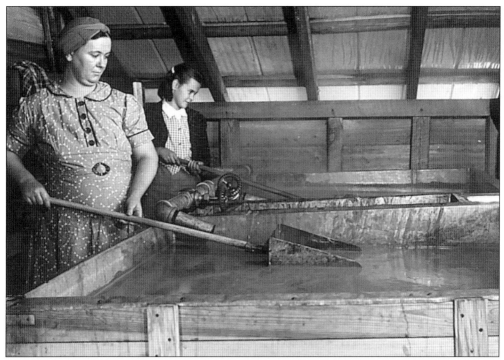

The J.C. Mixson farm ran a syrup mill in Early Branch (Hampton County). Here, juice is being skimmed for impurities that rise to the surface during cooking.

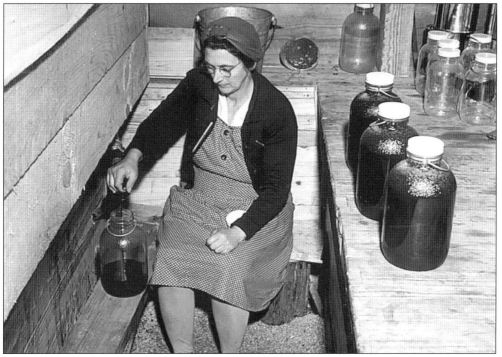

After cooling, the syrup was poured into jars. Sorghum syrup could be used as a sugar substitute or eaten on bread. Sometimes—to the delight of children—it was poured over popped corn.

Sugar cane, a crop usually grown in the Gulf States, was also grown in South Carolina. This patch grew in Williamsburg County in 1941.

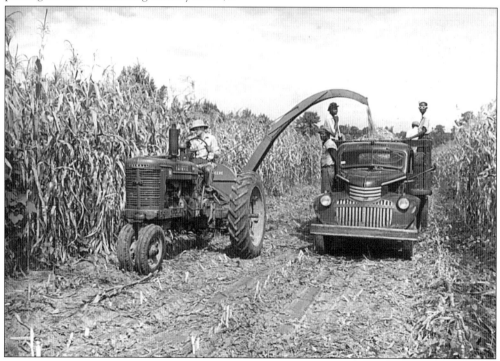

A mechanical silage cutter at Ridgeland cut silage in a fraction of the time it took to cut it by hand. This photo was taken in 1946.

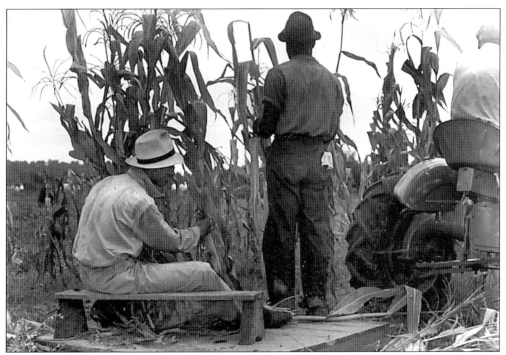

As the saying goes, "necessity is the mother of invention." This homemade corn cutter allowed small farms to produce silage quickly and easily. The cutter pictured here operated in Florence in 1941.

A tool with a dull blade had little value to a farmer; sharp tools were a necessity. For that reason, a well-equipped shop contained various implements for honing, grinding, and sharpening. The shop pictured here was in Orangeburg.

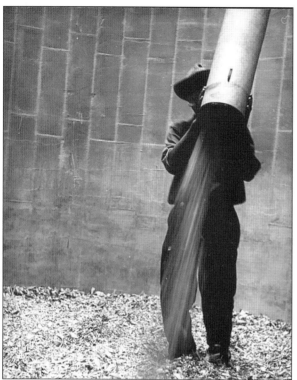

At Turkey Hill Plantation in Ridgeland, silage pours through a fill pipe into a silo. The silage, which is fodder converted to feed through the process of fermentation, provided a stable food supply for cattle during winter months.

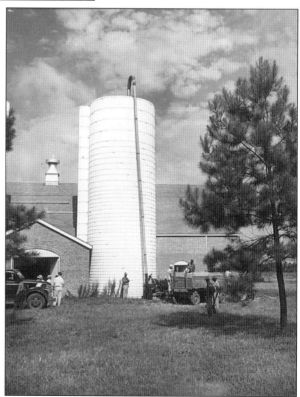

Various types of silos were found on farms throughout South Carolina. This permanent silo held silage for cattle at Turkey Hill Plantation in Ridgeland (Jasper County).

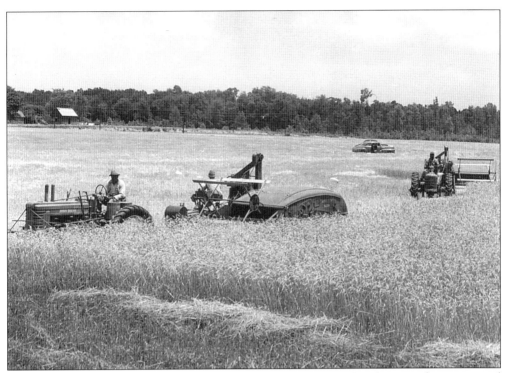

Wheat, usually identified with the Midwest, also grew in the south. These combines operated on the Hunt farm in Richland County in 1948.

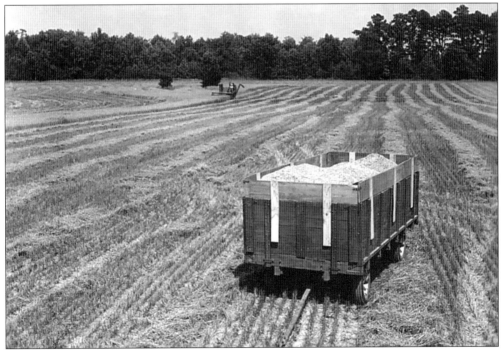

The strange patterns on this oat field in Allendale County were made by a modern combine. Combines enabled farmers to harvest greater yields with less labor.

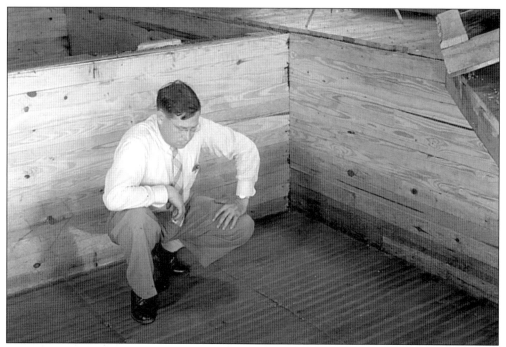

After grain was harvested, it was dried in an enclosure such as this one. The unique feature of this bin, located in Williston (Barnwell County), was its perforated floor, which allowed air to circulate and permit faster drying.

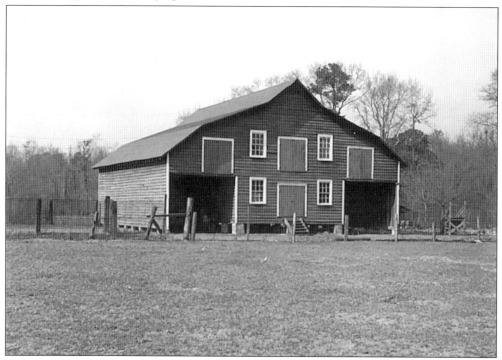

This barn doubled as storage for farm equipment and a tobacco pack house. It was located on the farm of F.W. Thomas in Williamsburg.

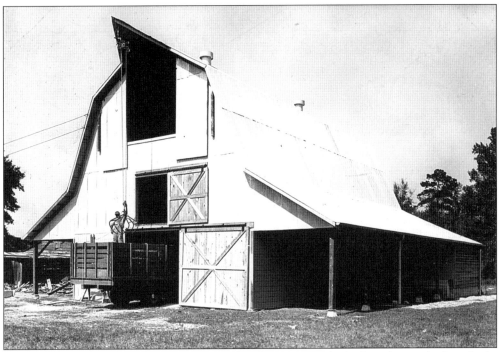

Note the construction of this barn in Lodge (Colleton County). At first glance, the barn looks like any other barn, but it was constructed of wood and iron on a concrete floor—something novel for 1939.

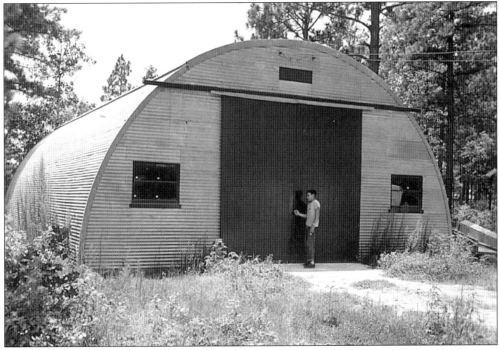

Throughout the Lowcountry, farmers experimented with various farm structures. This prefabricated metal building, a Quonset hut, could be built quickly and affordably.

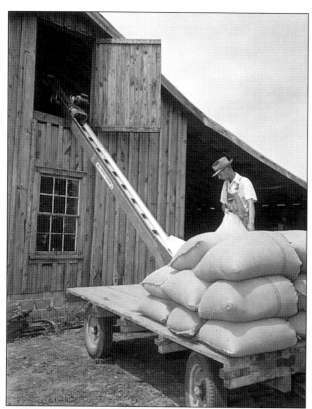

Laborsaving farm equipment came into general use in the 1940s. This Aiken farmer uses a conveyor to move grain to his barn loft—a task that had previously required a strong back.

Constructing a fence was an expensive task. Postholes, once dug by hand, were later dug mechanically. This group watches a demonstration at Ridgeland in 1946.

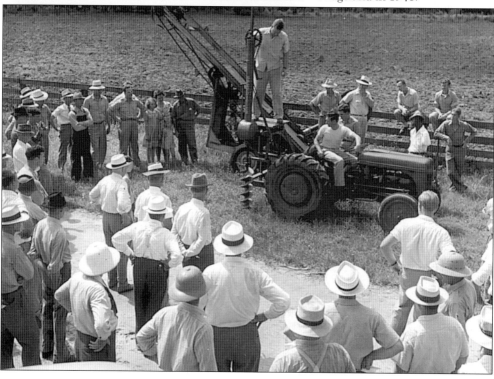

Two

FARM AND HOME

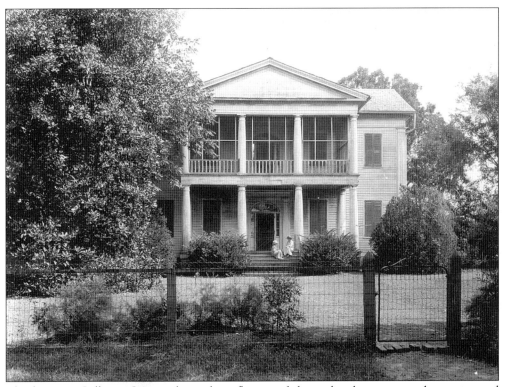

This house in Calhoun County shows the influence of classical architecture on the portico and columns. Houses of this kind were owned by affluent farmers.

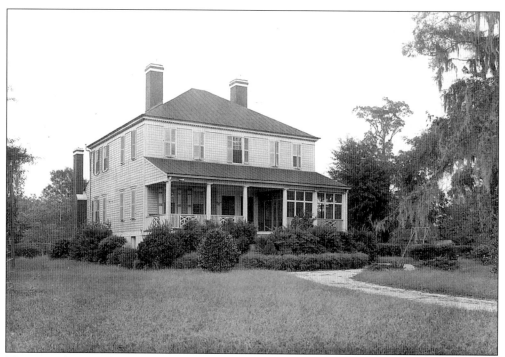

This is a photograph of the "Rocks" house in Eutawville. The house was built in 1800 by William Peter Gaillard. It is claimed that cotton was first grown profitably in South Carolina at this location. In 1939, when this picture was taken, it was the home of J. Rutledge Connor.

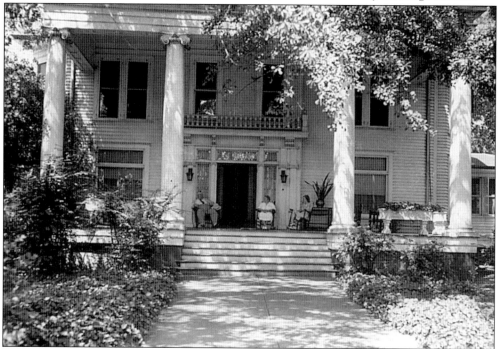

This grand Greek revival home in Marlboro conveys southern hospitality and charm. Homes such as these were owned by the upper class.

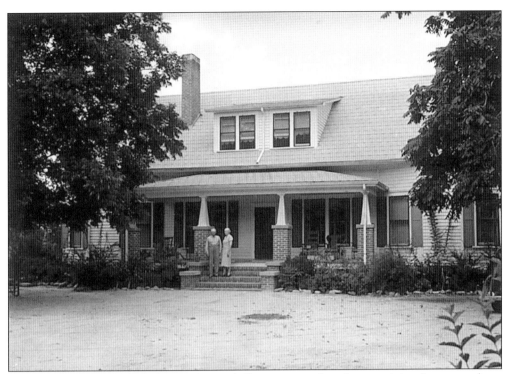

This farm home in Nichols (Horry County) illustrates another characteristic of some southern homes—the swept yard. In the 1930s, thick, green lawns, which required periodic applications of fertilizer—and mowing— were uncommon.

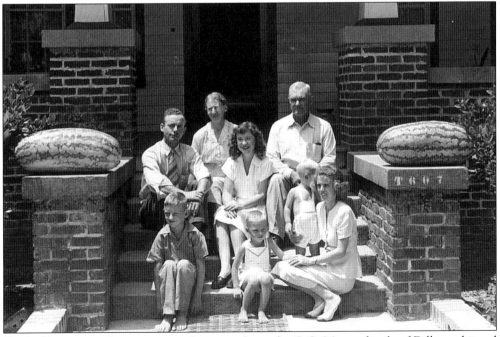

Flanked by watermelons grown on their own farm, the G.C. Meares family of Dillon achieved the honor of Master Farm Family in 1947.

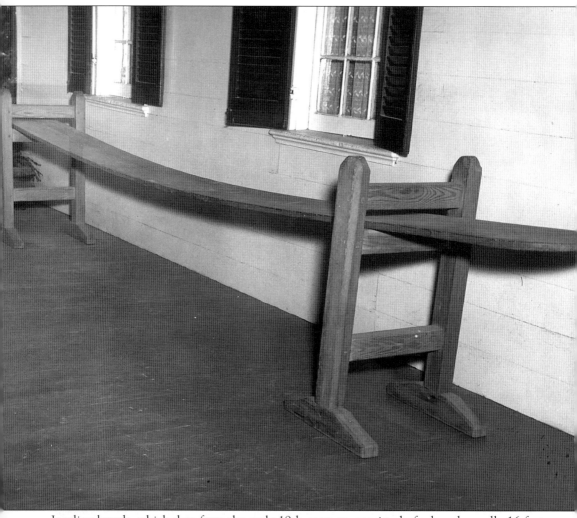

Joggling boards, which date from the early 19th century, consisted of a board, usually 16 feet long, suspended between two upright supports with curved bottoms. The rocking motion of the supports along with the "give" of the board produced an effect called "joggling." Children loved to play on them and courting couples often sat on them, each one sitting at opposite ends and ending up together in the middle. An old saying was that no South Carolina home with a joggling board would ever have an unmarried daughter.

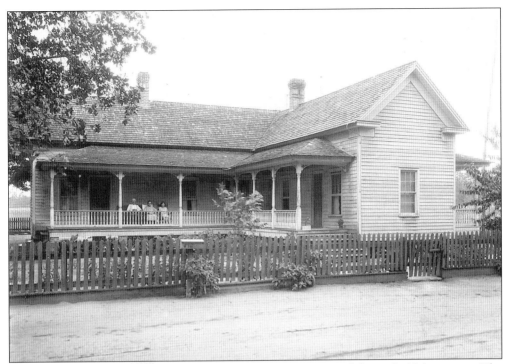

This country home in Loris typifies the southern architecture of the early 20th century. The long, covered porch was a hallmark.

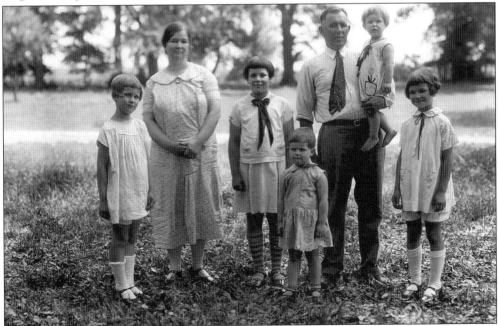

The J. Frank Williams family of Sumter County earned the distinction of Master Farm Family in 1928. The Master Farm Family program, sponsored by Clemson University and *Progressive Farmer* magazine, stressed the use of modern farm practices, good citizenship, and community service.

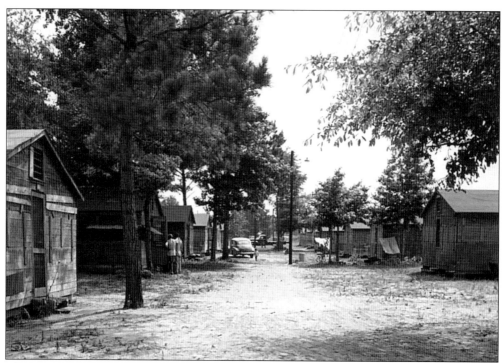

This is a view of John's Island farm labor camp that existed in Charleston County in the 1940s. The camp served John's Island, Wadmalaw Island, James Island, and St. John's Parish.

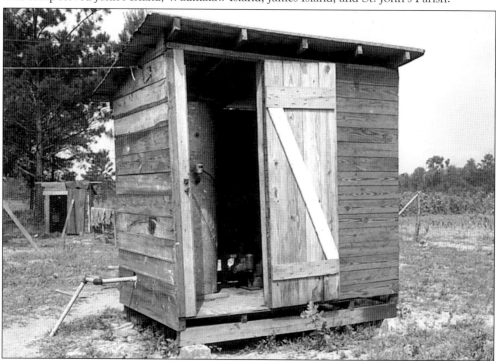

The privy is a sign of rural living. The name is derived from the Latin "privatus" meaning "private." This picture was taken at the labor camp on Wadmalaw Island in the early 1950s.

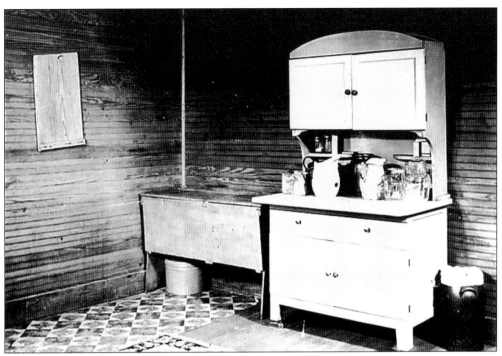

This Dorchester County kitchen interior dates from the 1920s. There was no running water, so water was brought from a well. Note the covered churn on the right waiting for milk to clabber.

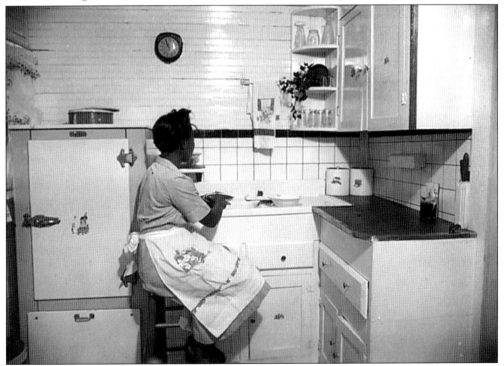

This is another photo of a farm kitchen in Dorchester, several years later. This kitchen was every woman's dream because it featured running water and an electric icebox.

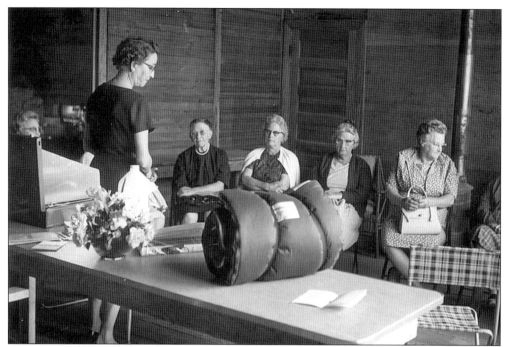

In the 1960s, with the threat of nuclear attack on everyone's mind, many towns conducted meetings to prepare families to be ready for such an event. Such a civil defense meeting, shown in the photograph above, was held in Orangeburg.

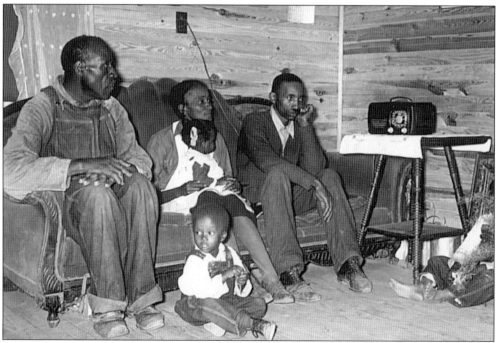

Before the days of television, radio served as the primary source of news and entertainment. This family is shown listening to their radio in November 1941—just days before the United States declared war on Japan.

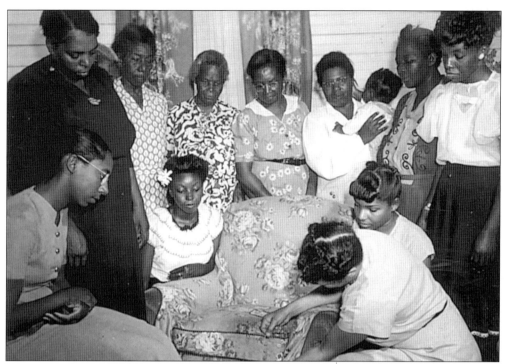

Home Demonstration, by today's standards, gets high marks for its emphasis on recycling and wise use of resources. These Orangeburg women learned the basics of upholstery from a Home Demonstration agent in 1949.

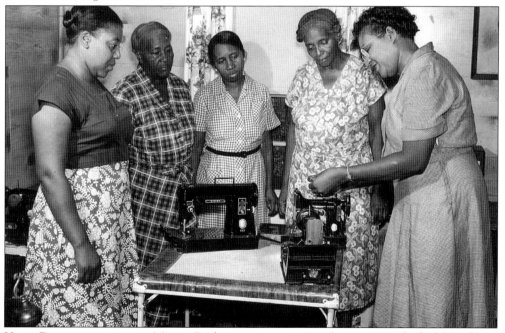

Home Demonstration agent Marian Paul instructs women on the proper method of threading a sewing machine. Seamstress skills enabled women to make clothing for their families and curtains for their homes.

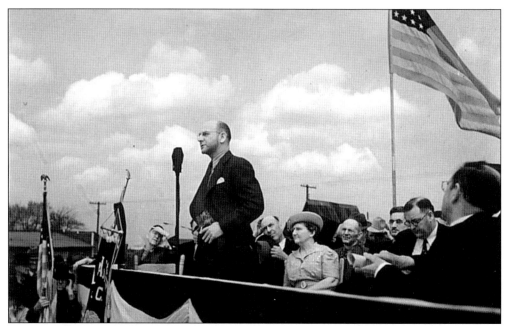

Life changed with the advent of electricity in remote areas. Sol Blatt, speaker of the South Carolina House of Representatives for more than three decades, addresses an audience at the opening of Lynch's River REA Cooperative at Pageland in April 1940. "I've tried to do the best I could for this state," Blatt said of South Carolina, "a state I love so much."

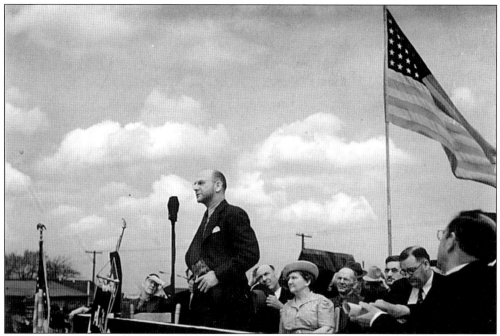

Fencing—specifically electric fencing—revolutionized the rural landscape. No longer could animals graze freely and without regard to property rights. Electric fencing has the advantage of being installed more cheaply than regular fencing and animals quickly learn to stay clear. This fence, used for hogs, cattle, and mules, was located in Turbeville (Clarendon County).

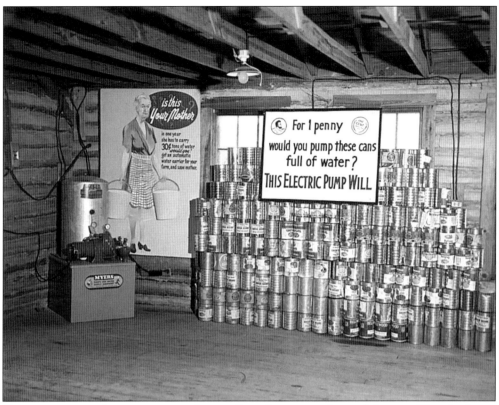

Electric pumps made carrying water from wells and springs a thing of the past. This display in Aiken is dated 1952.

This cartoon illustrates the benefits of running water for the rural home, but few people needed convincing.

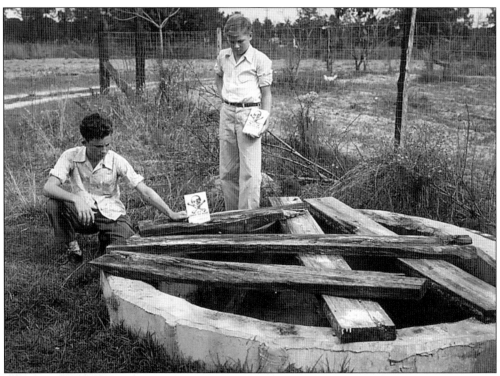

A fresh supply of water on the farm required constant vigilance. Improperly covered wells, could be fatal for human beings and animals.

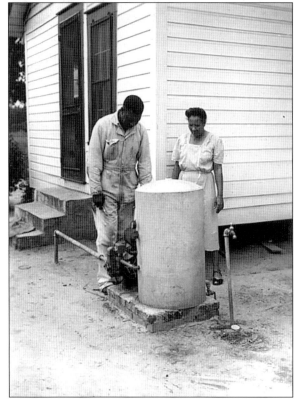

This Dorchester couple admires the holding tank for their water system that allowed them to have running water.

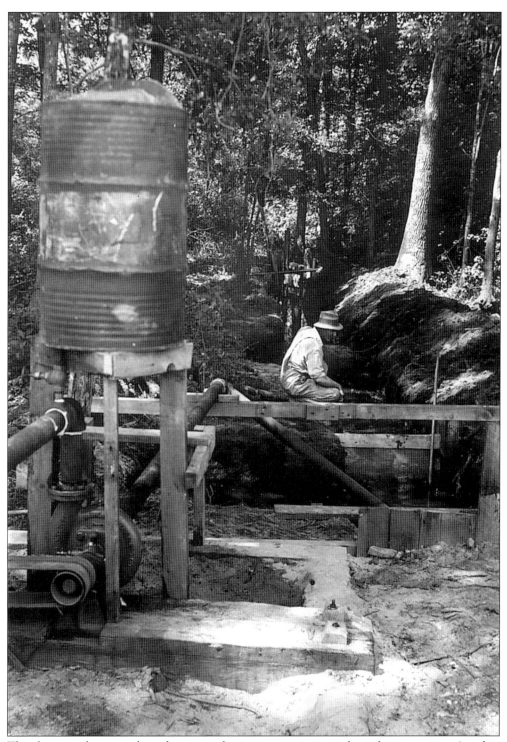

This homemade pump brought water from a reservoir to a farm for irrigation. Another common irrigation practice, on a much smaller scale, was to catch rainwater in a barrel near a downspout.

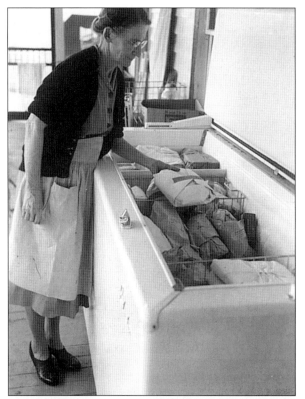

Home freezers became popular after the arrival of electricity. Freezing food was more efficient than canning. Mrs. G.C. Meares of Nichols (Dillon County) kept her family's food in a chest freezer.

With the advent of electricity, preservation of meat and dairy products vastly improved. This freezer locker in Aiken was operated by the Rural Electrification Administration in the 1940s.

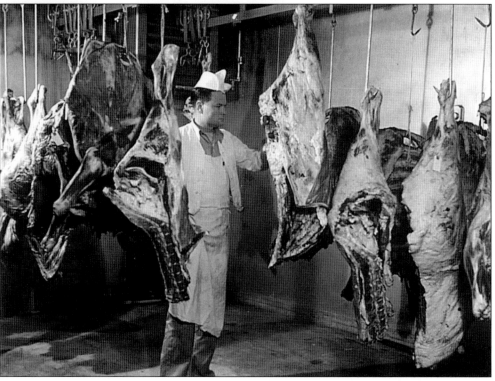

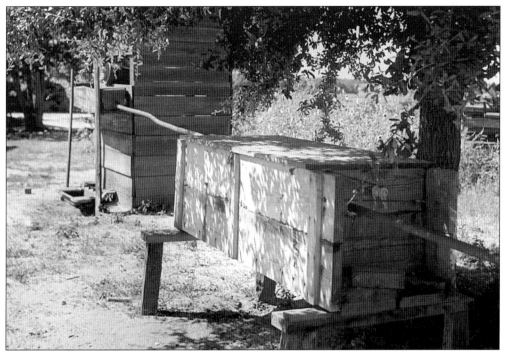

Before the arrival of the refrigerator, people put milk in wooden boxes through which cool spring water was piped. Milk coolers, such as the one seen here, were placed in the shade.

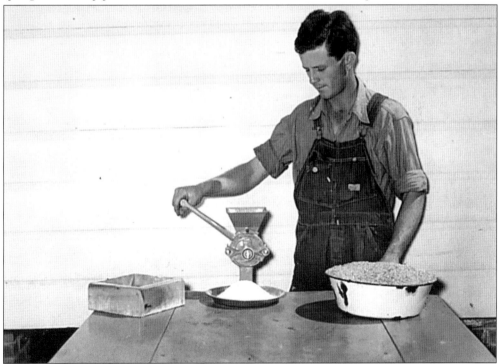

The old way of grinding at home required patience and "elbow grease." This Darlington farmer demonstrates grinding wheat using a hand mill.

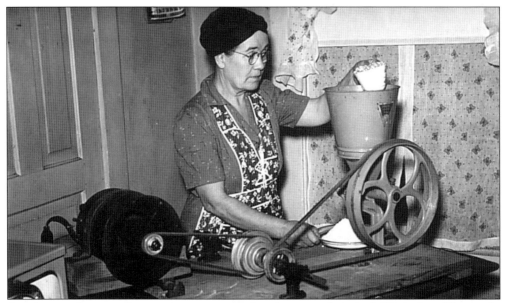

An electric wheat grinder saved time compared to the manual method. With the addition of a small electric motor, manual grinders became more efficient. Pictured here is a grinder at the Smith home in Mullins.

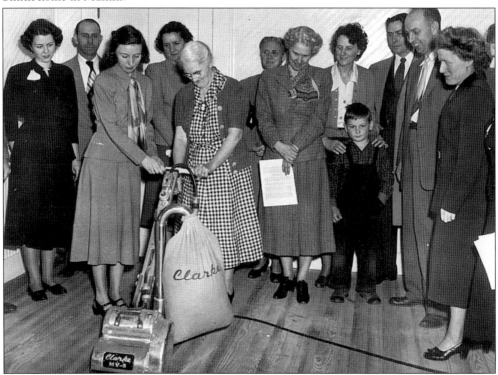

"Keep the machine moving at all times," advised this Calhoun County Home Demonstration agent on the proper use of a floor sander. Before the days of Home Depot "How-To Clinics," Home Demonstration agents provided guidance on food, household maintenance, and many other topics.

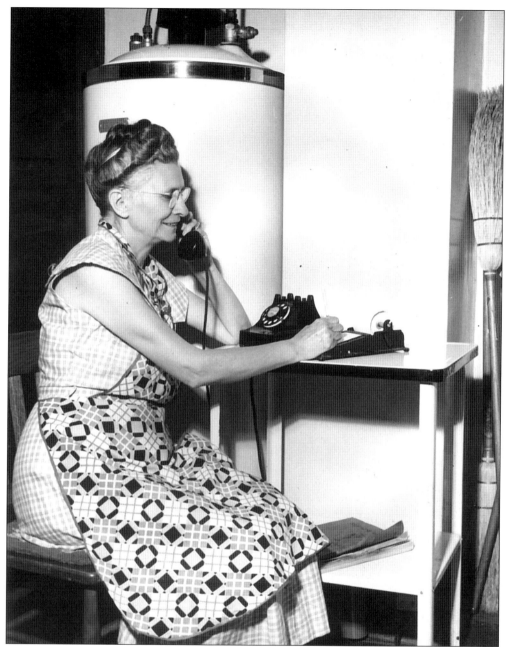

By the 1950s, many rural homes had installed telephones, although many homes shared the same line, which were named "party lines" because multiple parties could access the same line simultaneously.

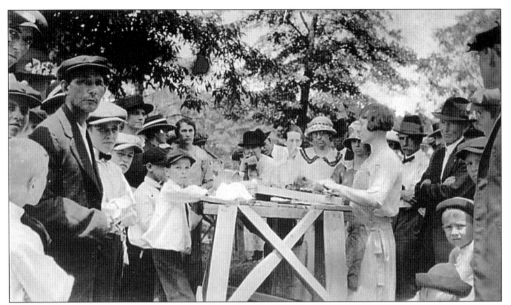

Capon, prized among poultry for its choice meat, is a castrated male chicken that is usually killed when it is 10 months old and weighs about 4 pounds. The *c.* 1920 photograph above depicts a caponizing in Calhoun County.

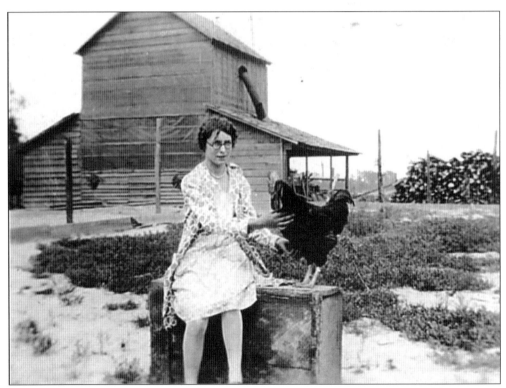

This unidentified young lady spent her spare time raising chickens. The year and location are unknown.

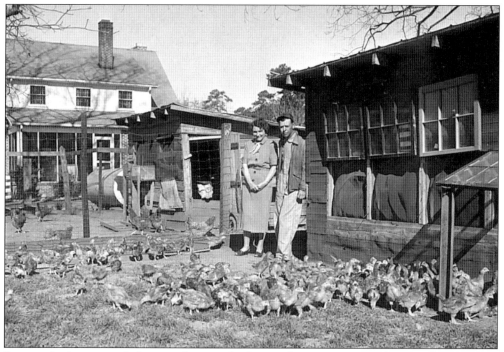

Raising chickens provided eggs and meat, which were the main sources of protein for most farm families. This hen house in Spring Branch contained a sizeable flock.

Farm families who raised chickens often sold eggs. Here Margaret Funderburk of Chesterfield loads eggs for market. During the next two decades, the egg production underwent major changes; it became almost entirely mechanized.

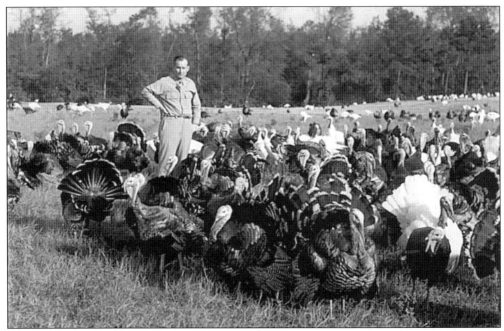

These turkeys on the range strutted their stuff for the camera. Records of turkey production in South Carolina were officially kept beginning in 1929. In that year, 88,000 turkeys were raised. By the year 2000, that number had reached over 10 million. These turkeys were raised on the Thomas farm in Sumter.

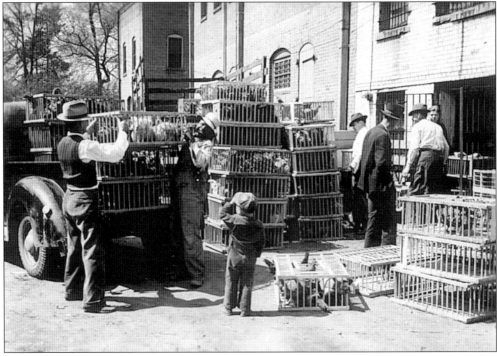

Before the days of modern poultry processing, farmers raised and sold their own poultry. This load of chickens heads to the market in Bishopville.

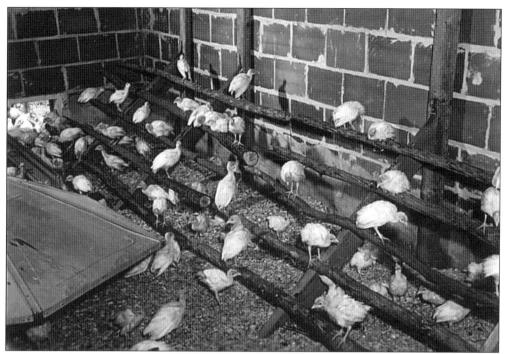

A chicken farmer on the Scottswood farm in Salters (Williamsburg County) devised a cost-effective and ingenuous way to provide roosts for his brooder house—pine saplings.

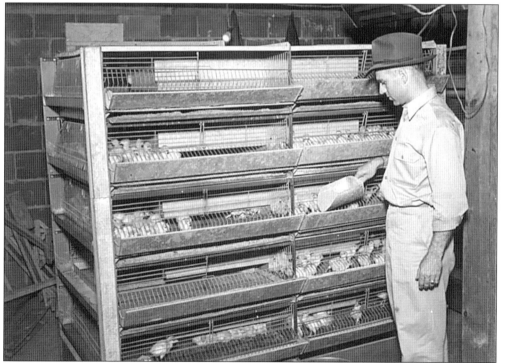

These "poults" are being fed in a brooder until they reach maturity for marketing. This brooder was located in Salters, South Carolina.

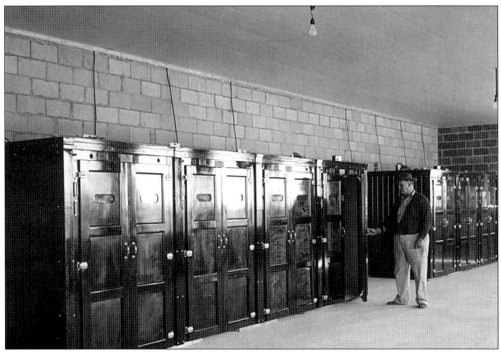

At first glance, these look like confessional booths in a church, but these cabinets are actually incubators for turkey eggs at a hatchery in Lexington.

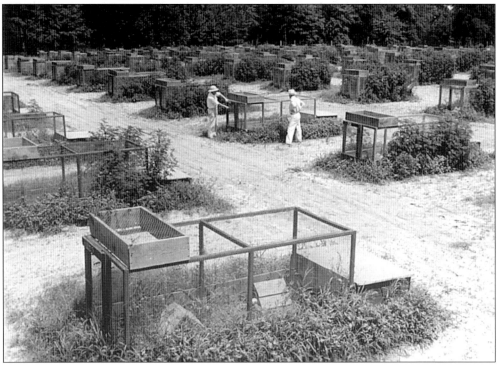

Although quail have been raised domestically, they are still "wild" birds compared to other fowl. This farm, which contained 120 pens, was in Jasper in 1939.

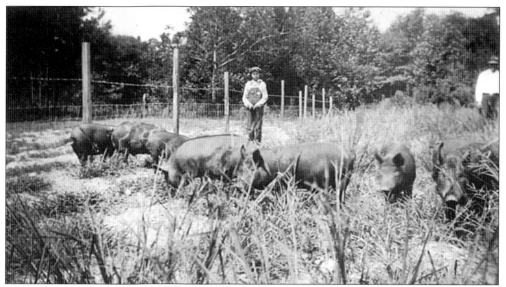

Henry Howard of Georgetown is pictured here with his prize-winning hogs some time in the early 1920s. Berkshires and Hampshires were common breeds.

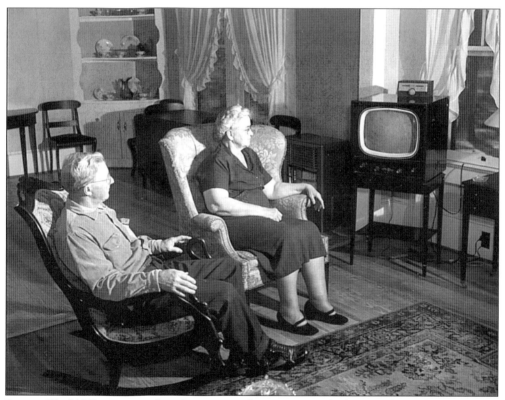

During World War II, most farm homes stayed in contact with the outside world through the medium of radio. After the war, however, television replaced radio. Here on the Baxley farm in Mullins, both television and radion co-existed, a phenomenon for 1953.

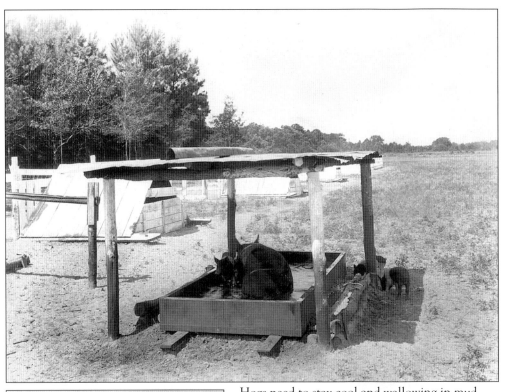

Hogs need to stay cool and wallowing in mud allows them to do it. This portable, shaded wallowing trough was one Beaufort farmer's contribution to hog heaven.

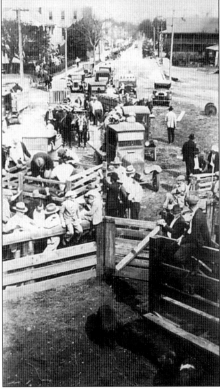

Conway was a bustling metropolis on the day pigs were shipped to market in 1929.

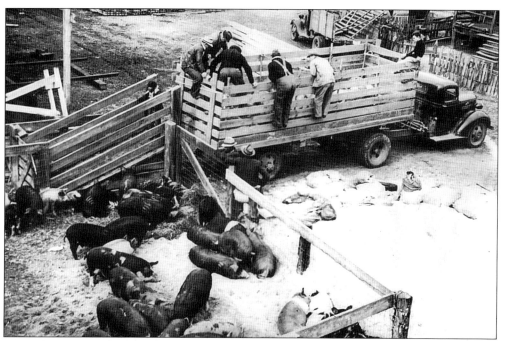

Once the hogs were sold, they had to be shipped to market. This scene was photographed at Monck's Corner.

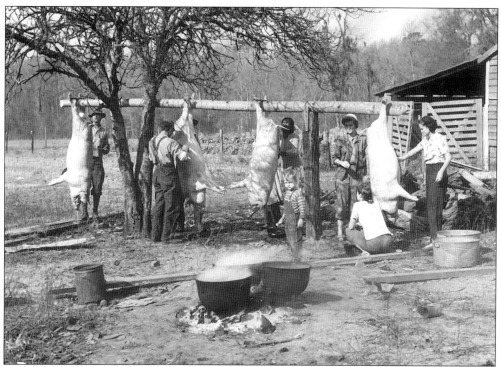

To reduce the threat of meat spoilage, hog killing always occurred after the first heavy frost and the process lasted an entire day. Associated tasks involved cleaning and dressing the hog and rendering lard. This hog killing occurred on the farm of F.W. Thomas in Williamsburg County.

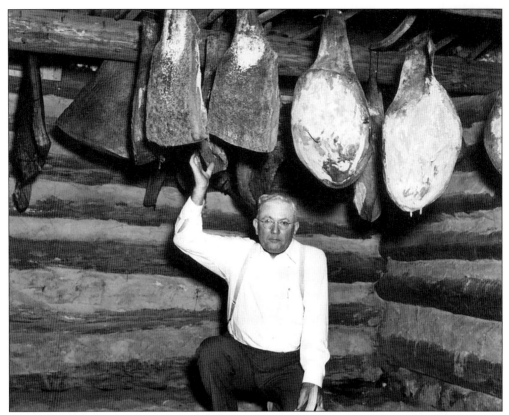

Curing meat at home required knowledge and patience. Curing could involve salt or sugar, depending on personal tastes and preferences. Here, George Macmillan of Marion displays some of his hams.

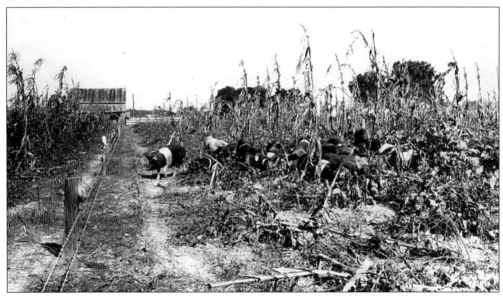

After the corn and soybeans were harvested, the owner of this field turned it over to his hogs to allow them to "hog it down."

This well-tended, private pond provided water for livestock. It is unique in that the owners landscaped the pond. Most farm ponds served a very practical function.

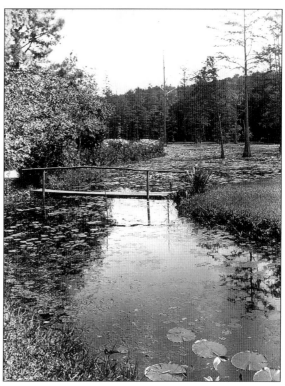

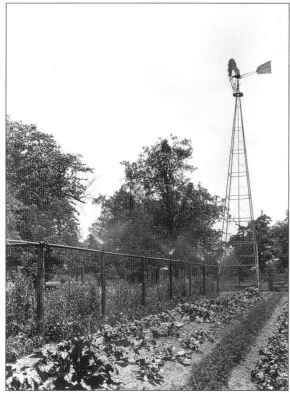

This innovative approach to irrigation occurred, surprisingly, in 1937, on the W.M. Manning farm, in Sumter.

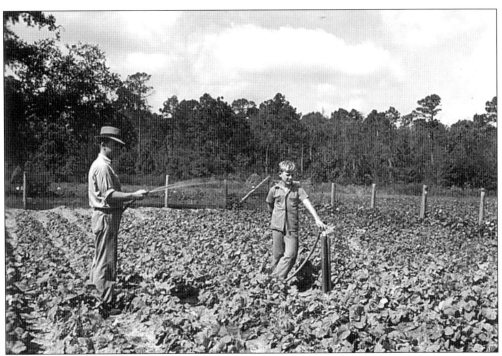

Nothing connotes southern life more than turnip greens and cornbread. Here DeLacy Long and his son of Woodville water their turnip patch during a dry season.

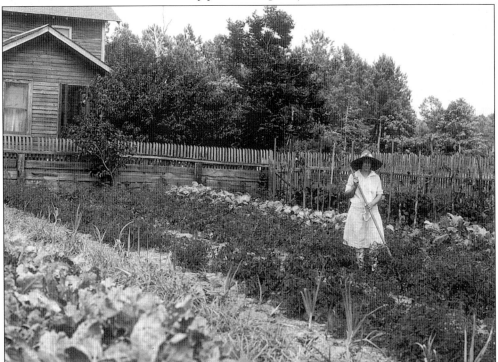

This Berkeley County farmwoman tends her vegetable garden. Small gardens produced enough for families to live on and, in many cases, to supplement household income.

Good squash is firm to the touch and has a uniform color and medium size. Extension workers E.H. Rawl and C.W. Carraway judge the quality of the squash grown on James Island.

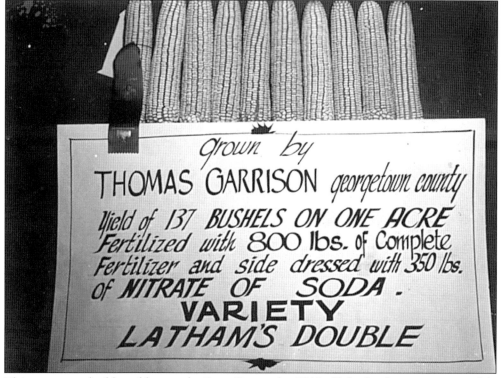

grown by
THOMAS GARRISON georgetown county
Yield of 137 BUSHELS ON ONE ACRE
Fertilized with 800 lbs. of Complete
Fertilizer and side dressed with 350 lbs.
of NITRATE OF SODA.
VARIETY
LATHAM'S DOUBLE

This corn won the blue ribbon at the State Fair in the 1940s. Hybridized corn was not widely grown at this time.

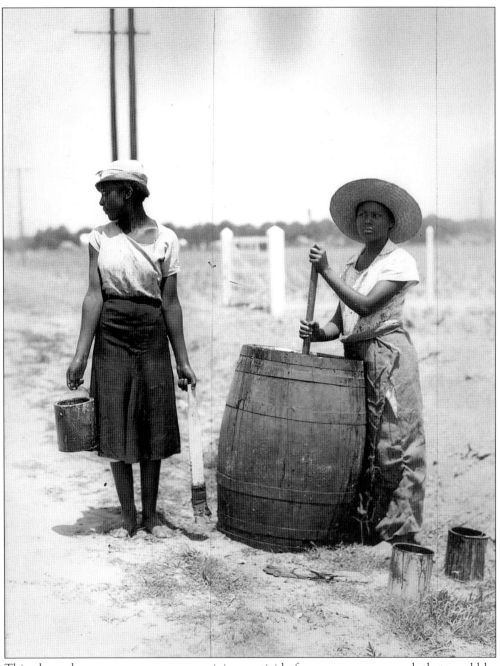

This photo shows two young women mixing pesticide for use on crops—work that would be governed by strict environmental guidelines today. The exact location is unknown.

With cabbage in one hand and onions in the other, this Orangeburg woman displays the fruits of her labor. Other crops grown for the home garden included radishes, potatoes, tomatoes, collards, okra, corn, and beans.

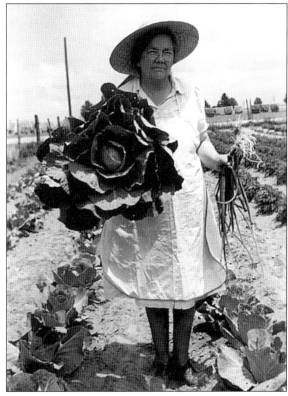

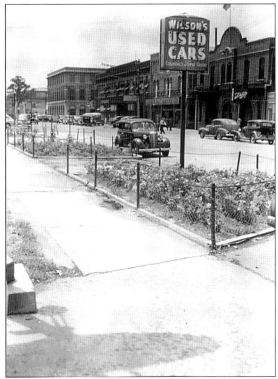

Rural meets urban at this curbside garden in Columbia. City dwellers who enjoyed fresh produce sought a garden spot anywhere they could find one. This photo was taken in 1939.

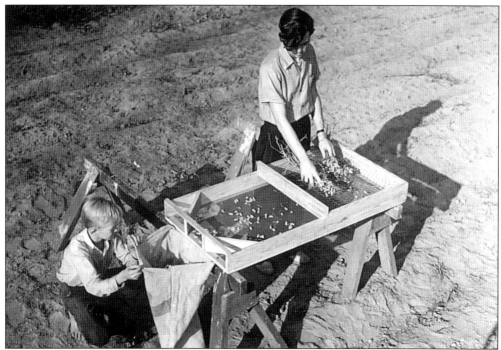

This homemade peanut picker reduced the time it took to harvest peanuts by one-third. The boys in this 1942 photograph are from Sumter County.

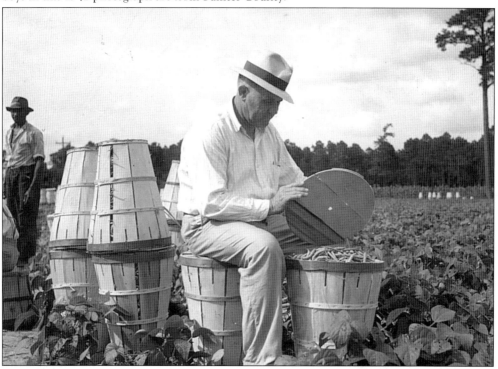

Mr. Brooks of Holly Hill (Orangeburg County) proudly displays a bushel of his white half-runner beans, 1940.

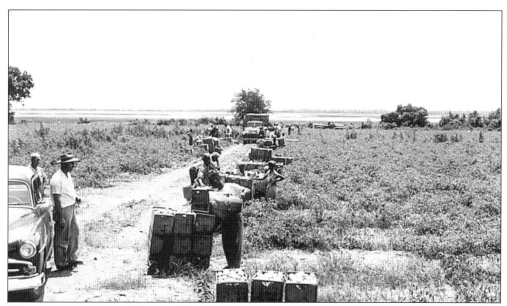

Tomatoes are a principal crop of the Lowcountry. In this Beaufort tomato field, pickers have put crates of tomatoes at the ends of rows to be picked up and taken to a packinghouse.

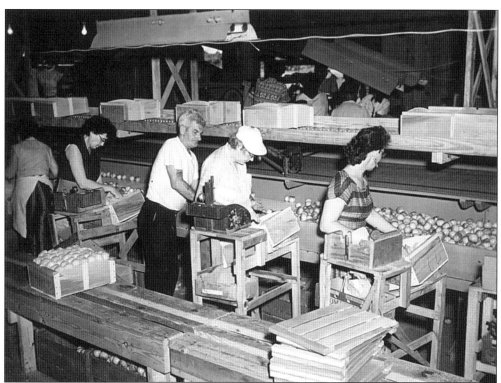

After the crates arrived at the packinghouses, the tomatoes were sorted by size and quality.

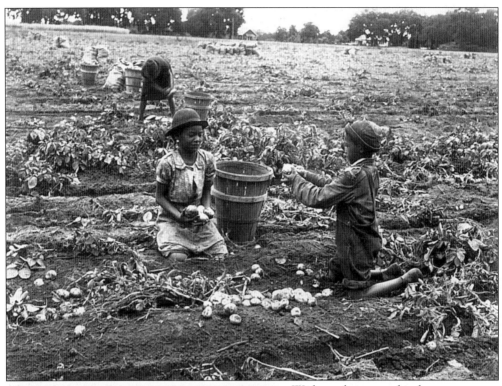

Without daycare or kindergarten, parents tended to their young while they worked. These youngsters take time out for some fun as their parents harvest the Irish potatoes on the Gray farm in Beaufort in 1940.

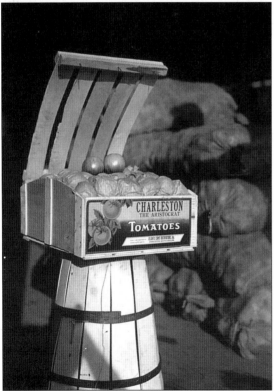

First quality "Charleston, the Aristocrat" tomatoes capture the attention of buyers at a produce market in Charleston, 1940.

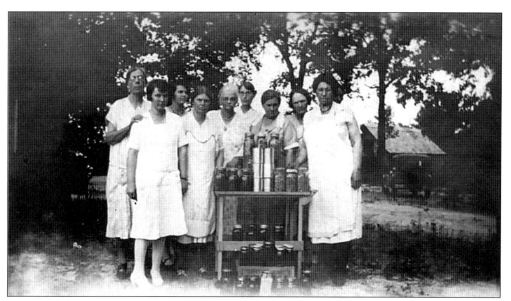

Dora Dee "Mother" Walker of Clarendon County served as a Home Demonstration agent for more than four decades. She is shown at the far right with other women enrolled in a home-canning class in 1930. Until home freezers came into widespread use, canning, along with drying and curing, were the only means of food preservation.

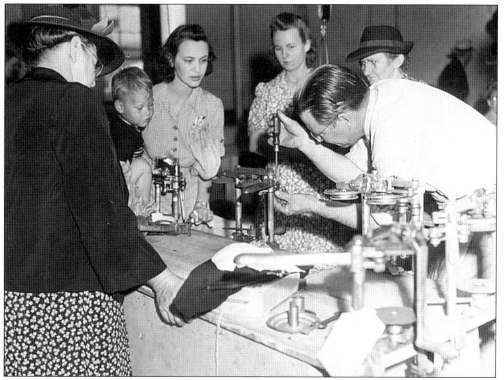

Preserving food at home usually involved canning, which required pressure cookers. Repair clinics, such as the one held here in Orangeburg in 1943, taught housewives how to make minor repairs to their cookers.

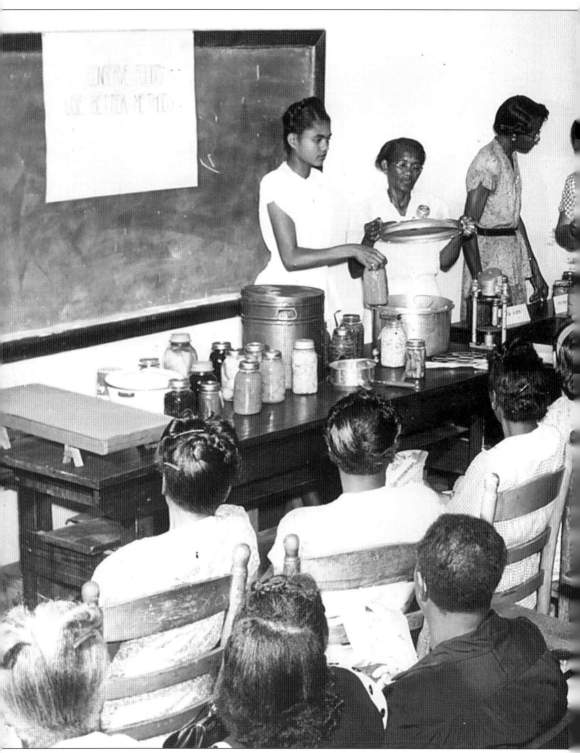

Because many farmwomen relied on canning to preserve their fruits and vegetables, they had to learn proper methods of canning. This food spoilage clinic was held at South Carolina State

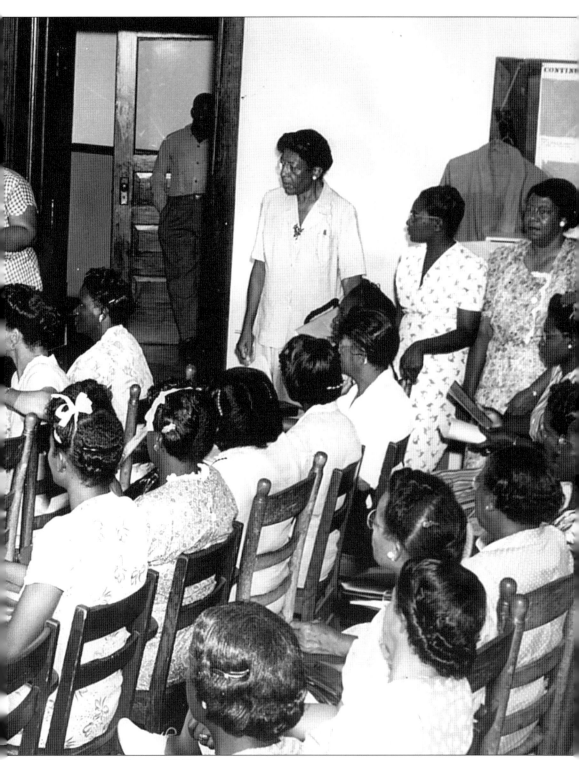

College in Orangeburg in 1948.

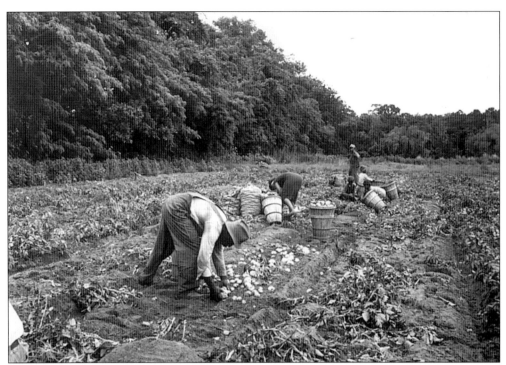

Workers needed a strong back for this job. This harvest of Irish potatoes occurred on the J.W. Gray farm in Beaufort in 1940.

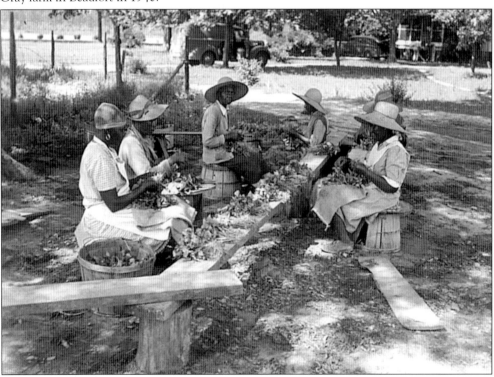

This group of women is sorting sweet potato plants on the J.T. Lazar farm in Florence, 1944.

Sweet potatoes were an excellent source of nutrition for many South Carolinians. Cooks served sweet potatoes in a variety of ways, such as candied, baked, boiled, and mashed. No potato was complete without a pat of butter. The most popular use for sweet potatoes, however, was the Southern specialty—sweet potato pie. The Extension Service issued a special bulletin in the 1930s devoted to recipes using these savory vegetables. The large sweet potatoes shown in this photograph were grown in Lee County

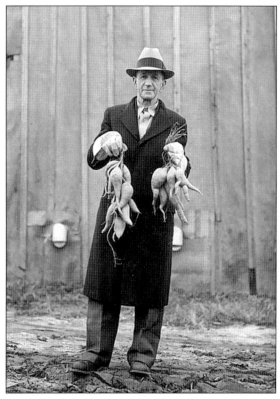

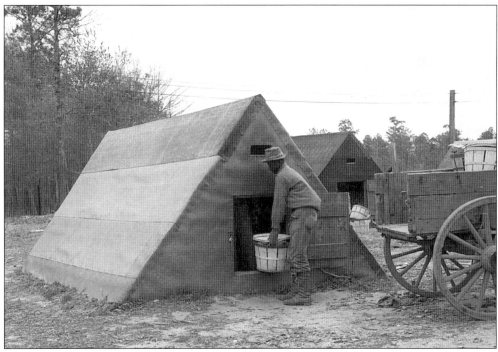

This unusual-looking structure was a storage house for sweet potatoes. Its primary advantage was the economical and uncomplicated construction.

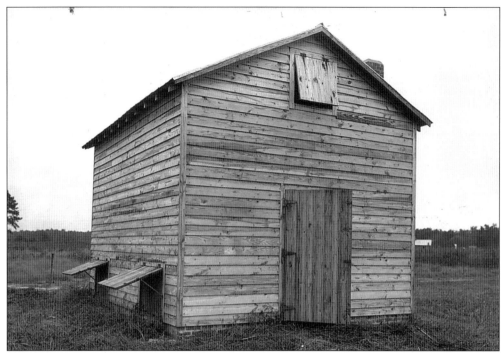

This building represents another kind of storage for sweet potatoes. It was located in Lee County on the Baskin farm. Special doors allowed proper ventilation.

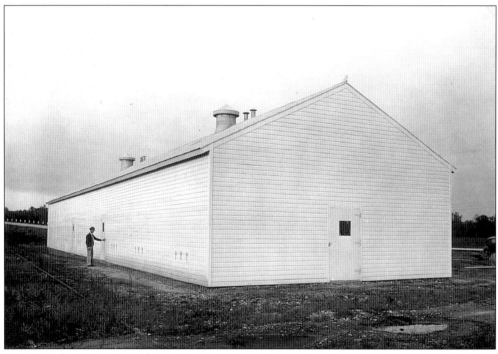

This large building, located on Ashwood Plantation in Lee County, held 12,000 bushels of sweet potatoes for curing.

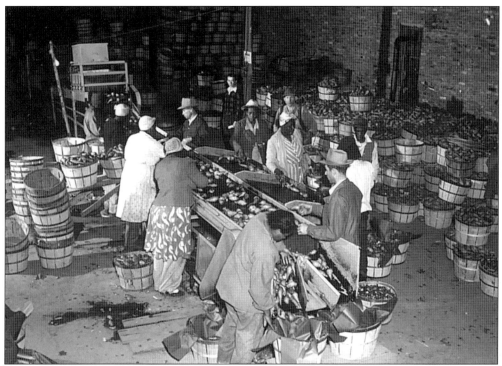

This packing shed at Loris became a beehive of activity at sweet potato harvest time. The year is 1950.

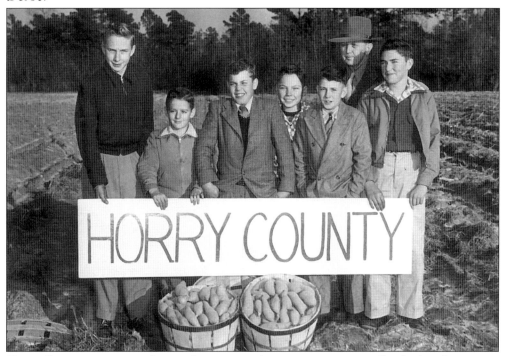

Horry County, just one of several potato-producing counties, proudly displayed its sweet potatoes and the boys who raised them.

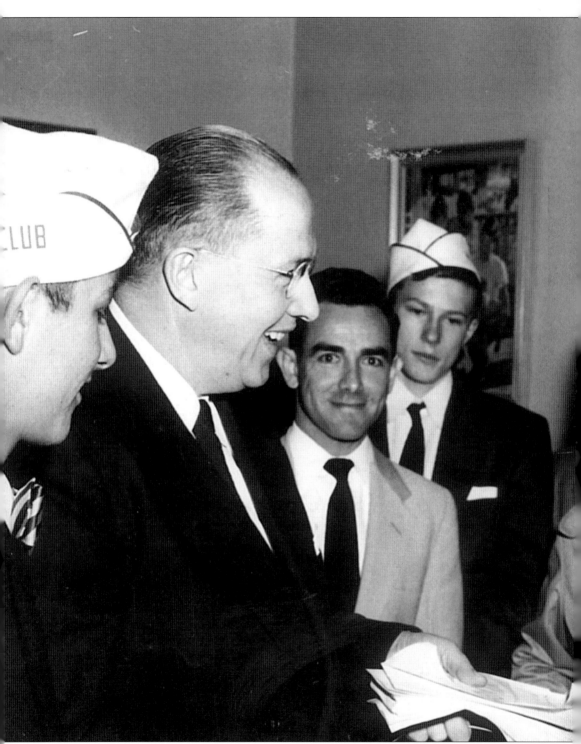

United States Secretary of Agriculture Ezra Taft Benson is pictured here receiving a delegation of prize-winning sweet potato growers in 1955. Eleven winners of the 4-H sweet potato production and marketing contest, which was sponsored by the Extension Service and A&P

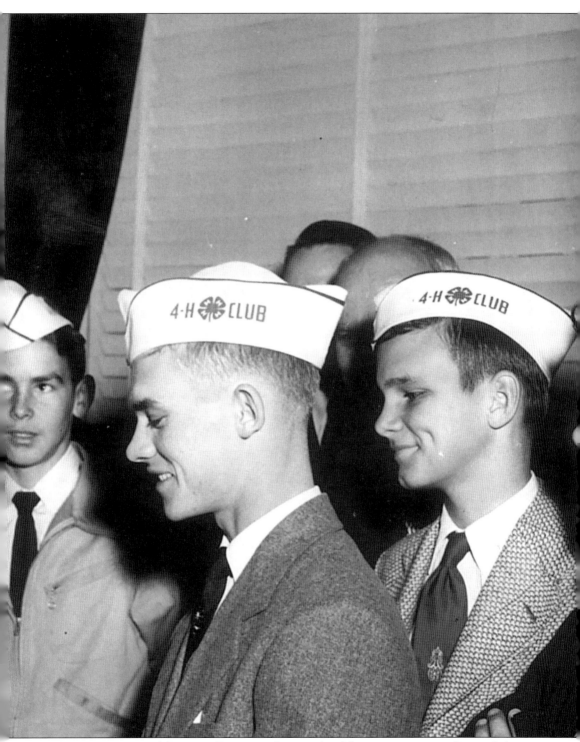
Tea Company, presented Secretary Benson with a sample of their prize potatoes. George Baker, a 4-H Club agent at Florence, was in charge of the trip.

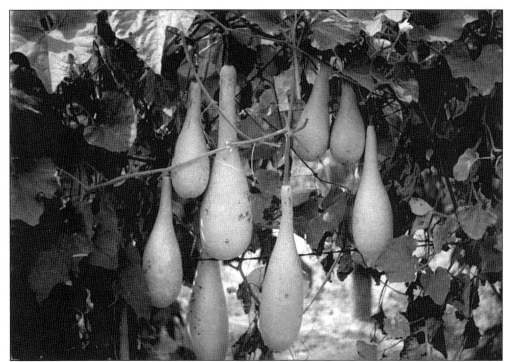

Calabash-style cooking, commonly found in eastern North Carolina and coastal South Carolina, originated with the use of long-necked gourds that were dried and used to scoop fried food from hot oil.

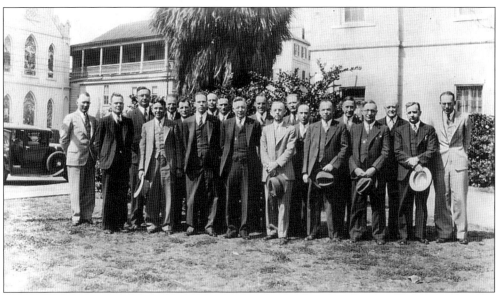

Before the days of cloning, there was hybridizing. This photo shows a meeting of collaborators at the Regional Vegetable Breeding Laboratory in Charleston in 1936. Hybridizing improved many plant varieties by making them more flavorful as well as making them resistant to pests and diseases.

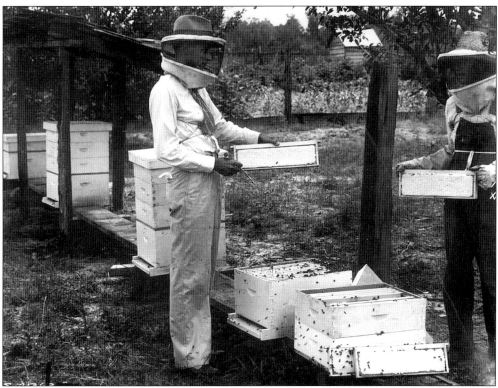

This apiary in Walterboro exhibited the latest techniques and equipment for 1936. Beekeeping provided a livelihood for some farmers, a pastime for others, and delicious honey for consumers.

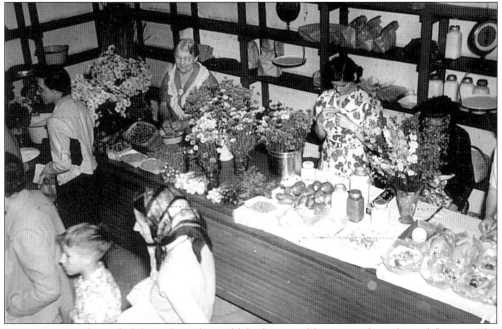

Many counties formed club markets that sold fresh vegetables, canned goods, and flowers. The Huntsville Club Market in Darlington brought extra income to many farmwomen.

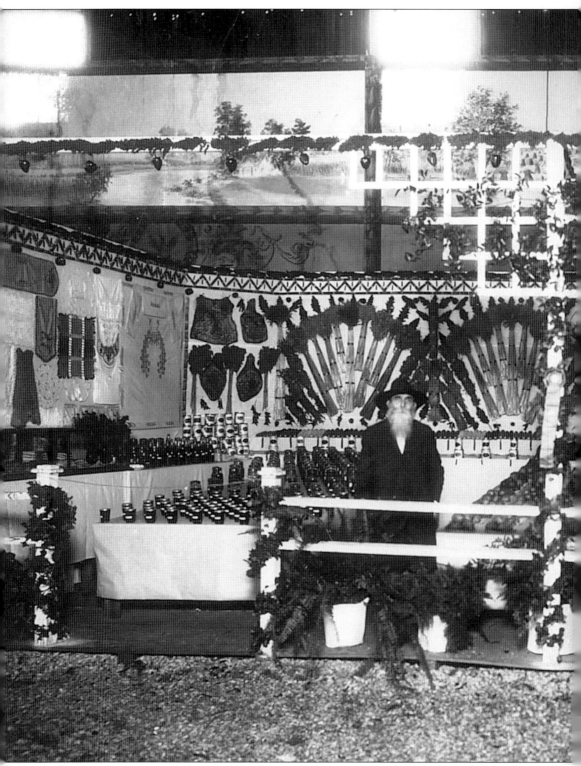

The State Fair has a long history of displaying the best agricultural products of South Carolina.

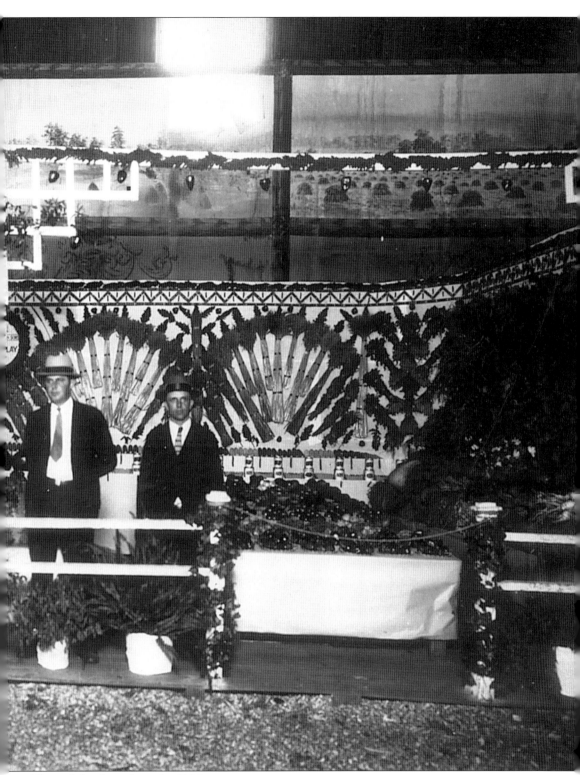

This exhibit dates from the 1920s.

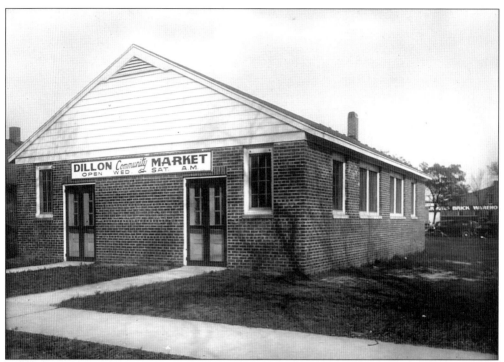

This community market operated in Dillon in the late 1950s.

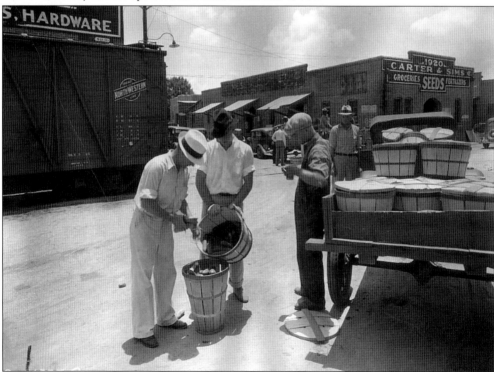

Here at Lake City Produce Market in Florence, farmers sold some of their best produce. These cucumbers were sold in 1936.

88

This photo shows another view of the Lake City Produce Market in Florence.

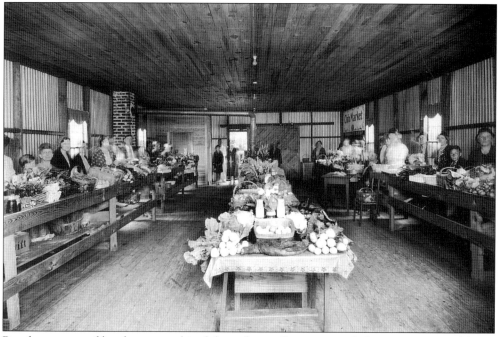

Run by a group of local women, this club market in Sumter provided a great variety of fruits, vegetables, and poultry at low cost. The photo was probably taken in the 1920s.

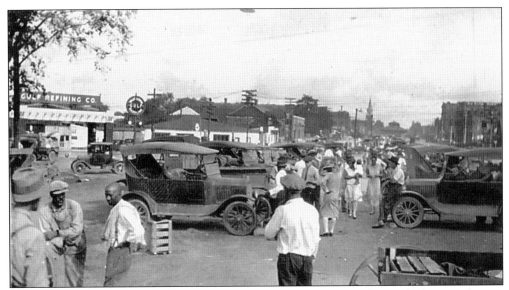

Farmers usually spent most of their time on the farm except when they took their produce to market. Here rural and urban life met. One of the busiest curb markets in the United States was in Columbia. This photo is from the 1930s.

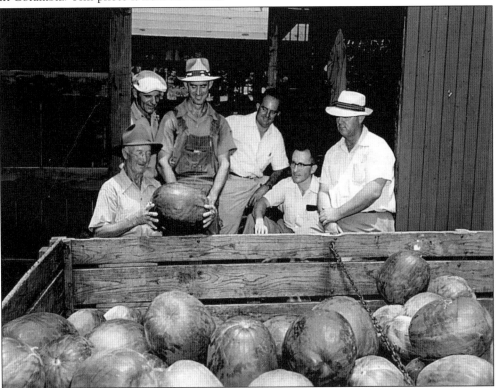

Nothing says success like a bumper crop of watermelons. These Barnwell farmers were pleased with their crop in 1952. By 2000, South Carolina ranked fifth nationally in watermelon production. Not pictured here, the most famous variety was Charleston Gray, a red meat watermelon with an oblong shape and hard rind, which made it easy to stack and ship.

Three

DIVERSIONS

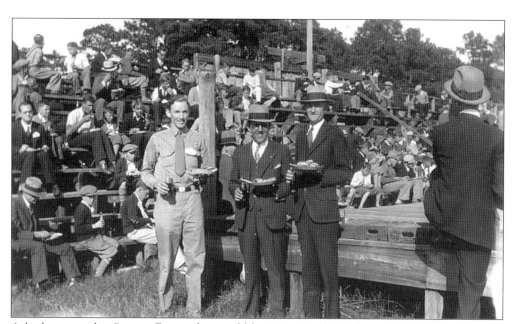

A barbecue at the County Fair—what could be more Southern than that? Here the Kiwanis and 4-H clubs sponsored the barbecue at the Sumter fair in 1932. The individuals pictured are unidentified.

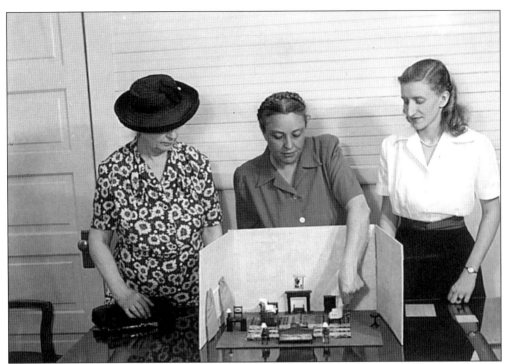

Interior decoration and modern furniture flourished in the post-World War II era. In those days, a housewife could make a career in decorating her home. A Home Demonstration agent in Colleton County works with two housewives to arrange miniature furniture.

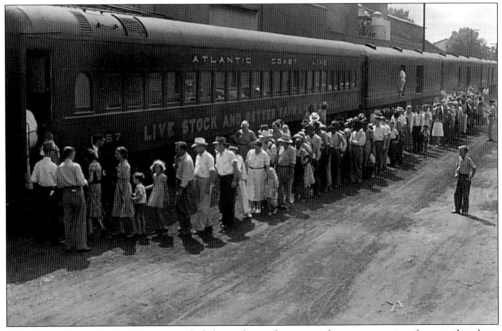

The Better Farm Living Train traveled throughout the state taking innovative farm technology and modern methods of cultivation to the people. In this 1948 photo, a line of visitors in Hartsville waits to enter the train.

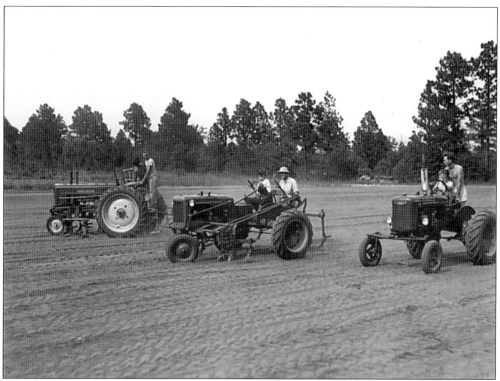

Boys and girls on the farm got their first driving experience not in the family car, but on the family tractor. These boys enjoyed racing tractors at Camp Long in Aiken in 1946.

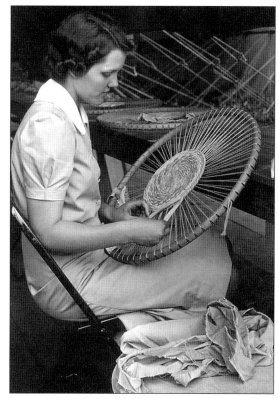

This unidentified woman is shown using a technique known as "coil basketry." The technique is believed to have originated in Western Africa.

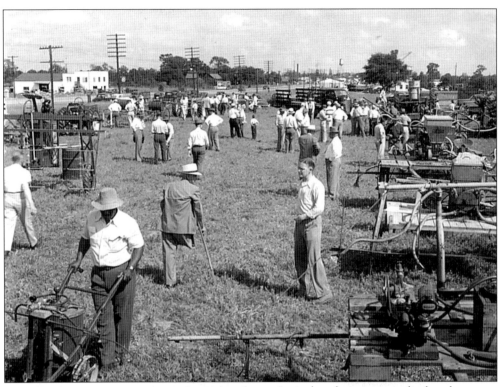

Agricultural expositions displayed
the latest farm implements. The
Pee Dee Experiment Station in
Florence hosted such events annually.
This one occurred in 1950.

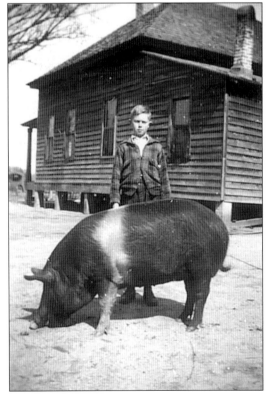

Addison Willis of Cottageville (Colleton
County) won first prize for his Junior
Hampshire sow at the state fair in 1920.

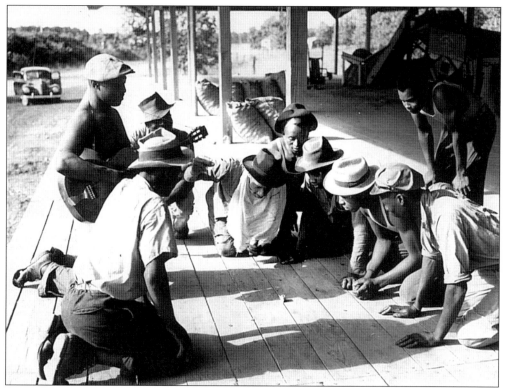

"Gimme snake eyes!" These men play a game of chance to pass the time until the arrival of the next truck at a packing shed in Charleston, 1940.

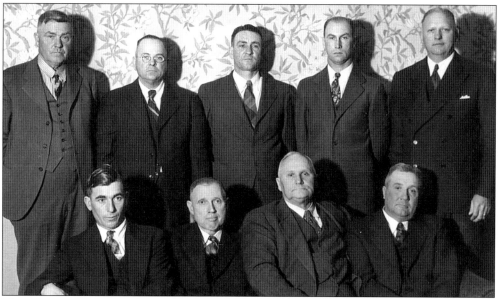

The Cotton Contest winners for 1943 were presented awards at the Jefferson Hotel in Columbia. Pictured, from left to right, are (top) W.F. Merck, Lewis Gainey, C.L. Baxter, J.D. Rouse, and R.F. Poole (president of Clemson College); (bottom) L.R. Gilstrap, J.V. Johnson, H.H. Herlong, and E.M. Duncan.

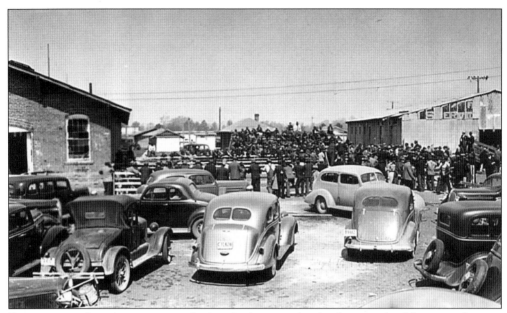

Farmers turned out en masse to livestock shows and sales because healthy animals were necessary for prosperity in farming. This sale in Florence was no exception. The year is 1939.

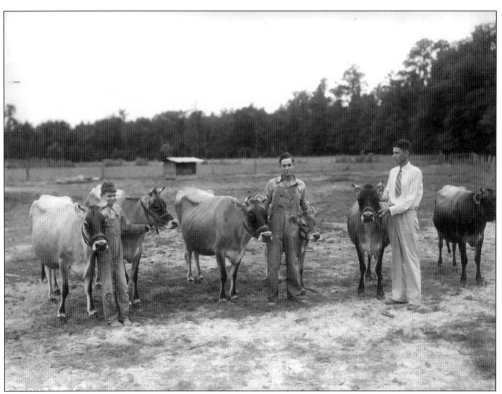

Parker Fralix, center, and his younger brother are shown with a Colleton County agent and their Jersey herd. Farmers prized Jersey cows because they produced milk with a high fat content. The milk was excellent for cream and butter.

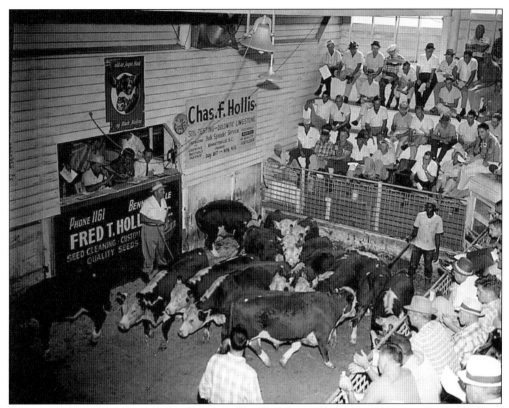

Livestock shows were events for the entire family. This calf auction at Lenox Stock Yards in Bennettsville occurred in 1961.

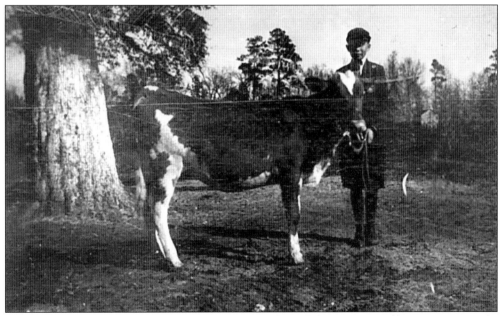

Pictured here is "Flodell Queen," a prize-winning calf, with her owner, William Eugene Smith. Smith belonged to the Lynchburg (Lee County) Calf Club in 1920.

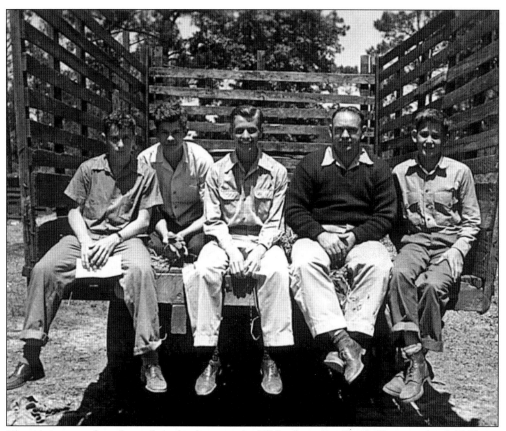

These winners relax after a day of judging at the Walterboro Fat Stock Show in April 1945.

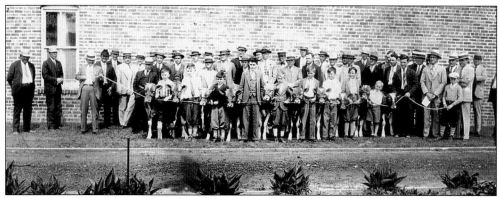

Calf clubs were established in many counties for boys raising calves. This unique photo captured boys with their fathers at a calf club meeting in Florence in 1937.

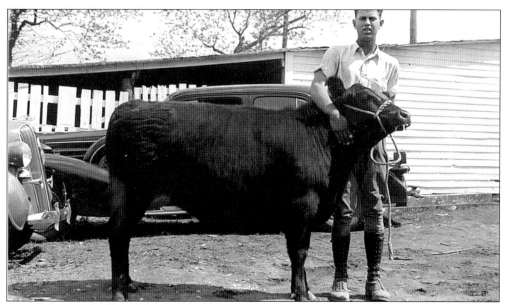

Raising livestock allowed boys and girls to gain experience and accomplish something at the same time. Joe Bryan of Allendale is shown at the Savannah Fat Stock Show in 1936. Prizes were awarded for various categories.

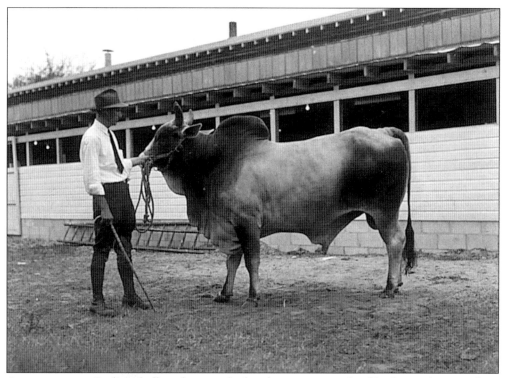

A prize-winning Brahma bull is photographed with its owner at the Charleston fairgrounds in 1947. Brahman cattle, which originated in India, were crossbred with American cattle to produce a species resistant to disease and heat.

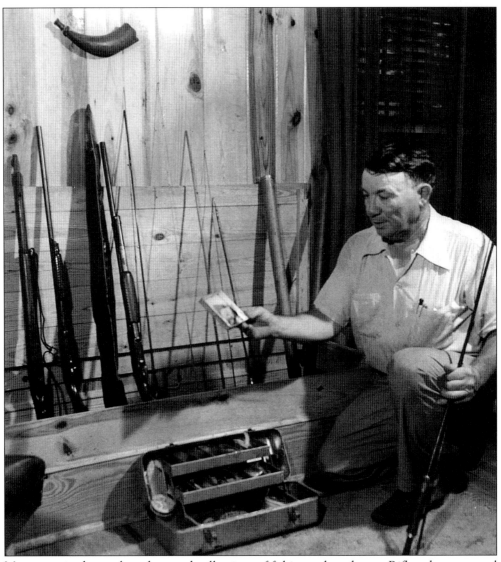

Many men in the rural south owned collections of fishing rods and guns. Rifles, shotguns, and pistols were a source of great pride, bragging rights, trading, and shows.

Marlboro County Agricultural and Educational Day
Saturday November 5th, 1910.

PROGRAMME.

9 to 11 a. m. Committee receiving and arranging Exhibits in Court House.

11 a. m. Address: Hon. J. E. Swearingen, State Superintendent of Education, Murchison School Auditorium.

11.30 a. m. Address: Prof. W. K. Tate, State Supervisor of Elementary Schools, Murchison School Auditorium.

12 o'clock, Organization of Teachers' and Trustees' Associations.

12.30 p. m. LUNCH. Tables provided for schools that bring lunches on the court house square.

1 to 2 p. m. Judges decide who are the prize winners.

Afternoon Meeting Held in Court House.

2 p. m. Awarding County Prizes. Mr. Ira W. Williams and Hon. J. B. Green.

2.30 p. m. Address: Mr. C. B. Haddon, of Clemson College.

2.50 p. m. Awarding Palmetto Flag to the School that has the best exhibit.
Prof. W. K. Tate.

3.10 p. m. Awarding Certificates to Boys of Boy's Corn Club. Supt. J. E. Swearingen.

3.30 p. m. Awarding prize to the Lady who has the Best Exhibit of Ferns, or Chrysanthemums, Hon. D. D. McColl, Jr.

Final: A Confederate Soldier dressed in his Suit of Grey. School Children and Audience sing "Dixie."

You are earnestly and cordially invited to come and add something to the attractions and pleasures of the day. All Exhibits are entered free. Try to bring something to add to exhibits.

Mrs. MARGARET CROSLAND,)
Mrs. A. G. SINCLAIR,)
Mrs. F. D. ROGERS,) Committee.
Miss ANNIE MAE McLAURIN,)

A. L. EASTERLING,
Co. Supt. of Education.

This 1910 program from Agricultural and Educational Day in Marlboro County outlined the day's activities. Such events mixed agricultural happenings with southern heritage.

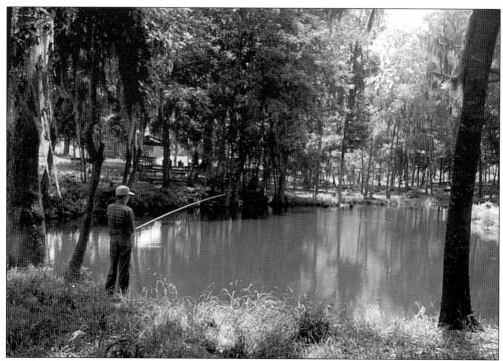

Nothing promoted relaxation like a few hours at a favorite fishing hole. This farm pond in Beaufort epitomizes serenity.

County agent Robertson instructs boys on the topic of root formation on corn at a 4-H camp in Allendale, 1926. Camps provided time for instruction as well as recreation.

Meeting space for 4-H clubs was not always readily available. These boys, for example, met at the Sumter County orphanage.

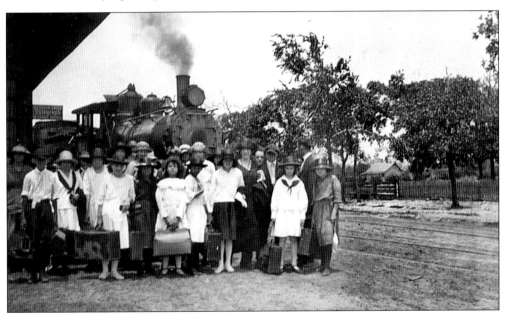

These young women attended a "short course," which was a workshop on a specific subject, at Myrtle Beach in 1924. Short courses dealt with topics in food preservation, gardening, and clothing.

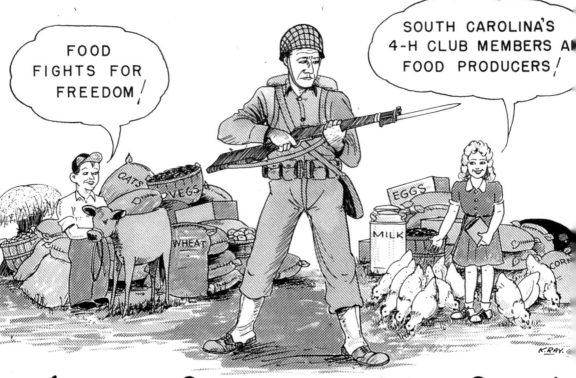

The United States sold war bonds during World War II to fund the war effort. The 4-H club members planted victory gardens and raised food and money to support United States troops.

During the years of World War II, families were encouraged to grow their own food to assist in the war effort. This photo shows 4-Hers visiting the governor's mansion victory garden.

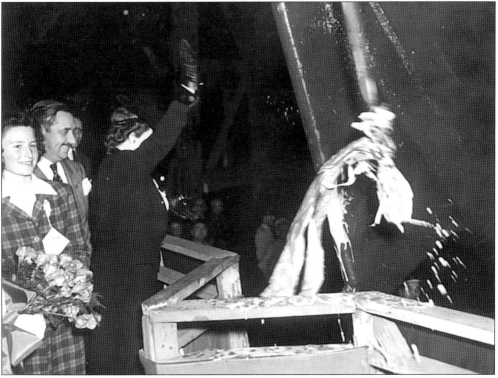

South Carolina 4-H members raised money for a victory ship in honor of Congressman A. Frank Lever in December 1943. The ship was built with funds from bonds sold by 4-H members in the fourth war bond sale. Two million dollars was required and $3,654,178.47 was sold. Mrs. A.F. Lever is shown christening the ship *Liberty*.

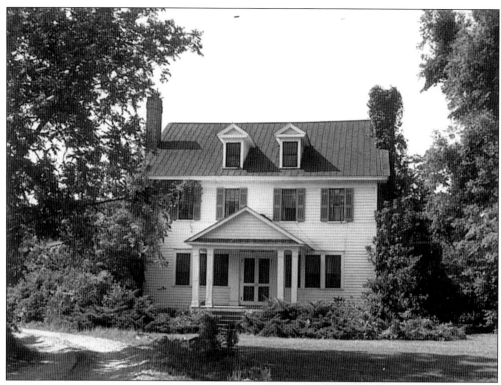

This is the home of A. Frank Lever, co-author of the Smith-Lever Act that created the Extension Service in South Carolina. The house is located in Lexington.

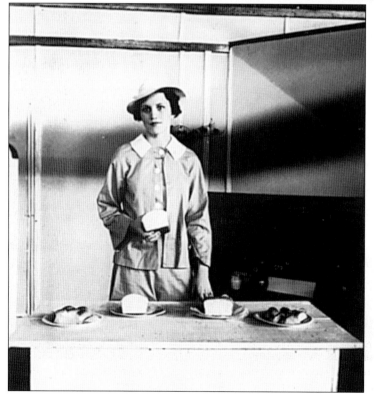

A demonstration on the nutritional value of bread was given at the State Fair in Columbia in the 1920s. Changes in the milling of flour brought changes in the nutrients found in bread.

In a scene that presaged "urban green," these two unidentified men planted pine trees on Courtyard Square in Orangeburg in the 1920s.

"Dress reviews" occurred regularly in most schools. These young couturiers won the dress review contest at Bamberg High School in 1944 for dresses they made themselves.

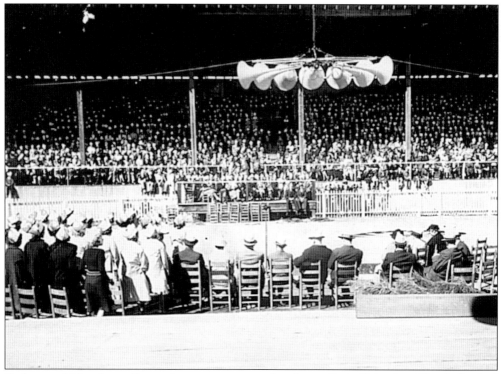

Each year, 4-Hers from all over the state came together for a rally in Columbia. This "rally day" was held at the State Fair in 1937. No exact figures are given for number attending, but a safe guess would be approximately 5,000.

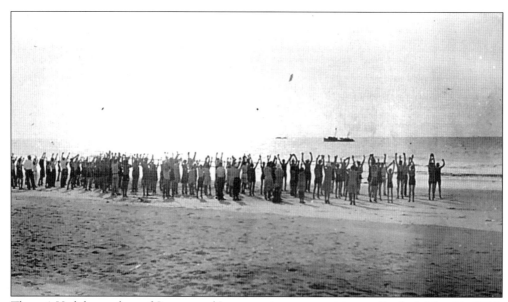

These 4-H club members of Sumter and Lee counties are exercising on Pawley's Island in 1931. The 4-H philosophy emphasized mental and physical well being.

Each year, the State Fair was held in Columbia and winners and representatives were received at the governor's mansion. This scene is from 1943.

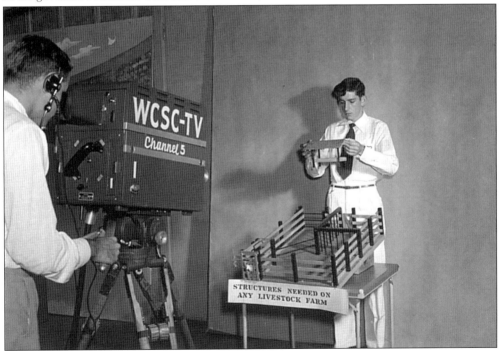

Station WCSC-TV in Charleston carried the 4-H Hour program. This 4-H clubster gave a demonstration on farm structures in 1953. Four-H was the only organization that afforded youth opportunities to appear on television.

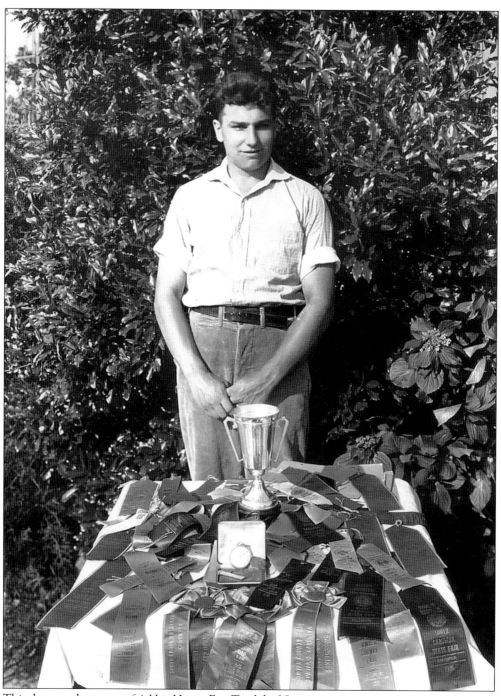

This decorated veteran of 4-H is Henry Fox Tindal of Sumter.

TO ALL 4-H CLUB MEMBERS OF THE UNITED STATES:

Today our country relies on the determination and courage of its youth to see us through to victory. In the years to follow we shall look likewise to our youth for leadership in building a world of peace. Through 4-H Club work you have demonstrated that you are a powerful influence in this direction.

In being ever mindful of your responsibilities as each of you pledge your head, heart, hands and health to the service of your club, community and country, you are furthering your own wholesome development and that of your own family and community. Moreover, through assuming such responsibilities you are helping materially in building a world of progress, justice and mutual understanding.

I trust that rural boys and girls everywhere will respond to the roll call of 4-H Mobilization Week, March 4 to 12. For this year more than ever, members of the 4-H Clubs will be among the shock troops on the food production front to give that extra impetus to the war effort so essential to ultimate victory.

Franklin D Roosevelt

President Franklin Roosevelt involved 4-H members in the war effort. This letter encouraged young people to become involved in food production.

Officers of the Midway Club (Calhoun County) are proudly wearing their prize-winning corn boutonnieres in 1923.

County agents used various modes of transportation to visit farms. O.P. Lightsey of Jasper County, pictured here in 1920, was fortunate to have a vehicle.

In 1856, Gov. James Hammond and a group of farmers organized the Beech Island Agricultural Club, first called the A.B.C. Farmers Club founded a decade earlier, in Aiken County. The purpose of the club was to disseminate agricultural knowledge. These pictures were taken at the 100th anniversary in 1946.

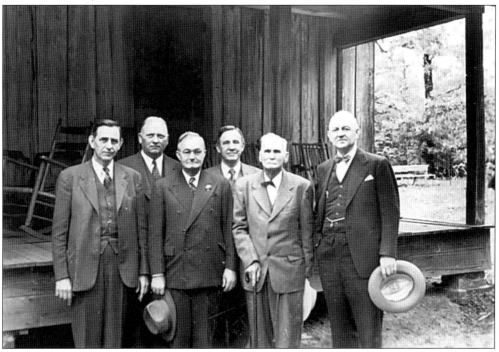

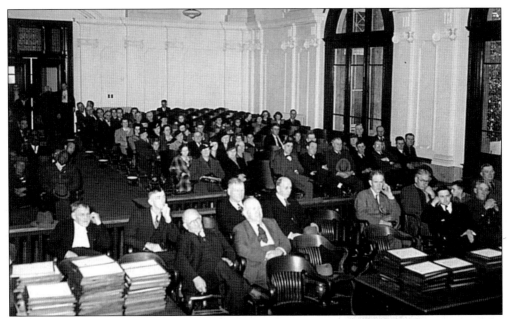

People responded by turning out in large numbers to the Better Farm Living Program. The Better Farm Living train carried exhibits throughout the state. This meeting was held at the courthouse in Sumter in 1941.

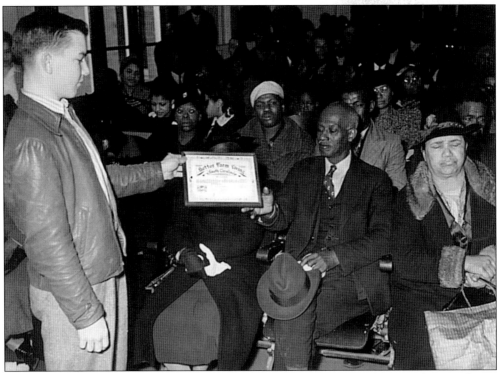

This unidentified farmer is shown receiving a Better Farm Living certificate at the courthouse in Sumter in 1941. The Better Farm Living program of the Extension Service encouraged farmers to employ modern farming methods and practices in agricultural production.

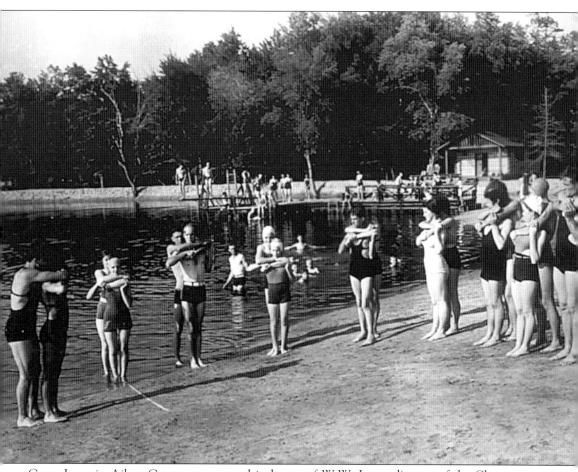

Camp Long in Aiken County was named in honor of W.W. Long, director of the Clemson Extension Service (1913–1934). Summer camps for 4-H clubs were held at Camp Long beginning in the 1930s. The photo shows participants in a Red Cross life-saving course. The swimmers are illustrating the "hand stranglehold and release" move, 1936. Today, the camp is known as the W.W. Long 4-H Leadership Center.

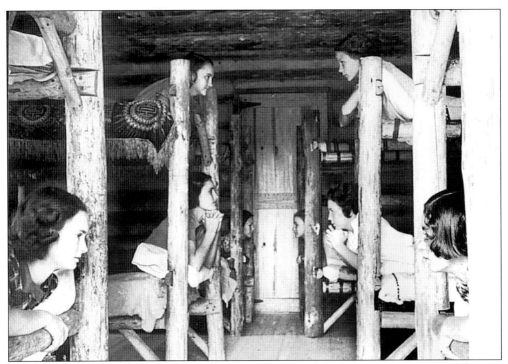

Sleeping accommodations at Camp Long consisted of bunk beds, but socializing until the wee hours of the morning made up for any discomfort the campers might have experienced.

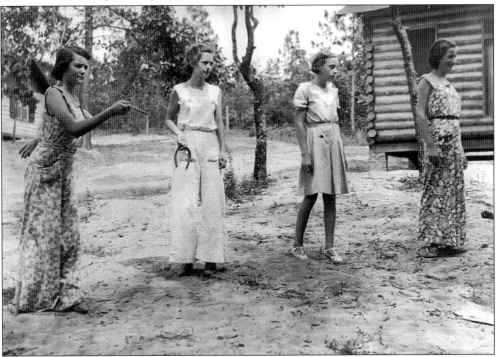

Pitch a ringer! These girls at Camp Long passed the long days of summer pitching horseshoes. Televisions and radios were unheard of at camp.

Ross Hawkins of Darlington won the Grand Champion award for the pigs he raised.

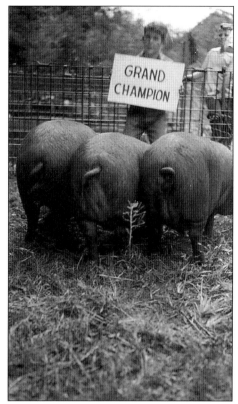

These 4-H boys at the Sumter Children's Home carried on projects involving pigs, cattle, and poultry. The boys performed most of the labor to build the houses and pens for their animals. The Children's Home was supported by the city of Sumter, Sumter County, the Duke endowment, and individual donations. The land was given by Martha W. Graham.

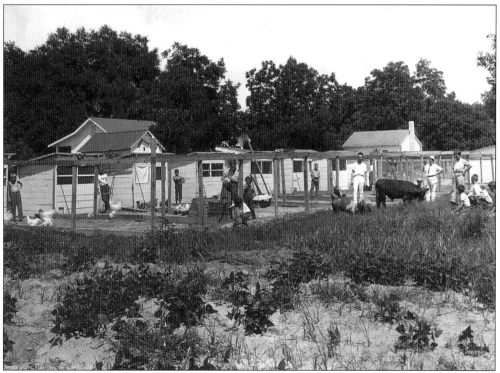

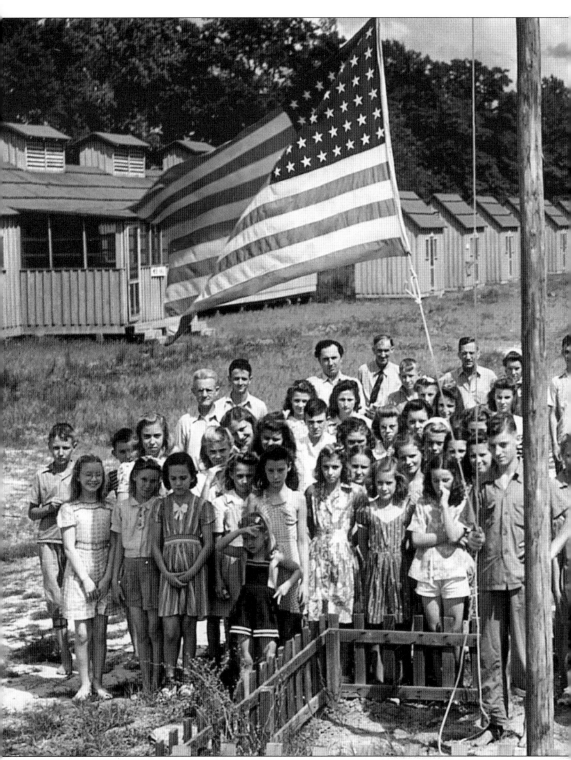

Raising Old Glory at Camp Bob Cooper stirred patriotic feelings in these youngsters. Citizenship was a cornerstone of the 4-H pledge: "I pledge my head to clearer thinking, my

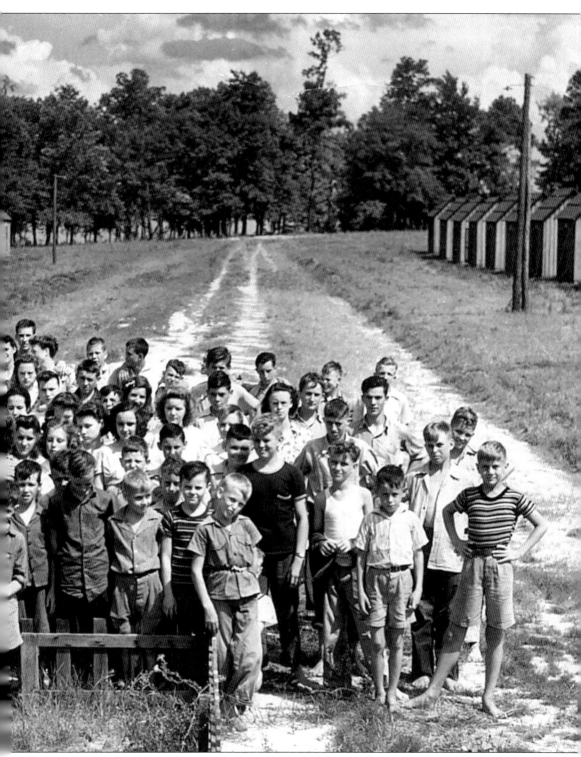

heart to greater loyalty, my hands to larger service, and my health to better living for my club, my community, and my country."

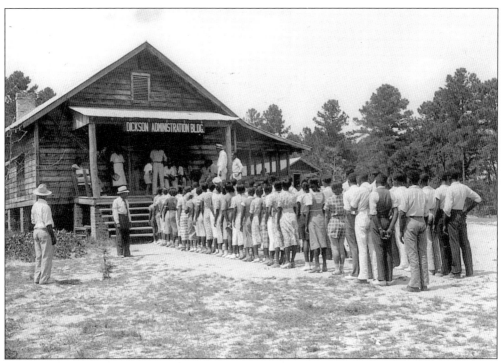

This long line to the mess hall at Camp Dickson did not dissuade hungry campers.

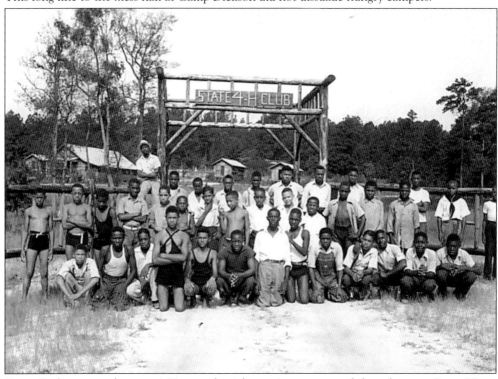

Camp Dickson served as one 4-H camp for African-Americans and the other was Camp Harry Daniels. This picture was taken in 1940.

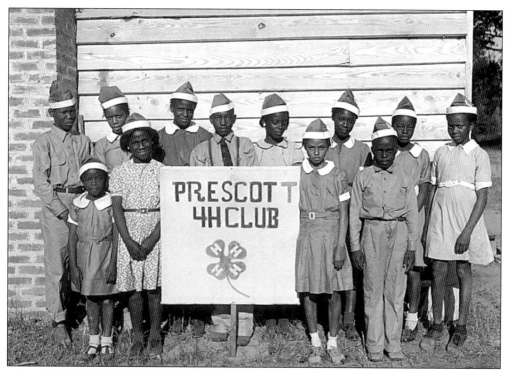

Life in South Carolina, as in most southern states in the 1940s, reflected segregation. The educational system and 4-H clubs were not exempt. "Negro 4-H clubs" for African Americans existed in most states. The Prescott 4-H club pictured here met in Beaufort County.

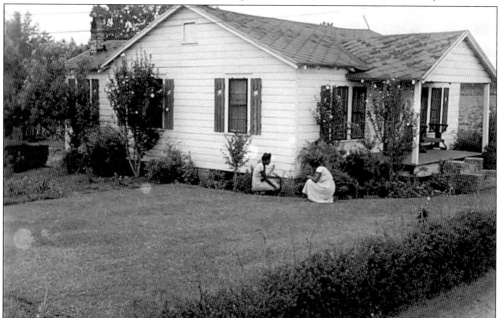

Landscaping the farm home brought a sense of pride in home ownership. This house in Dorchester reflected a trend popular in the 1940s and 1950s, putting the family initials on the window blinds.

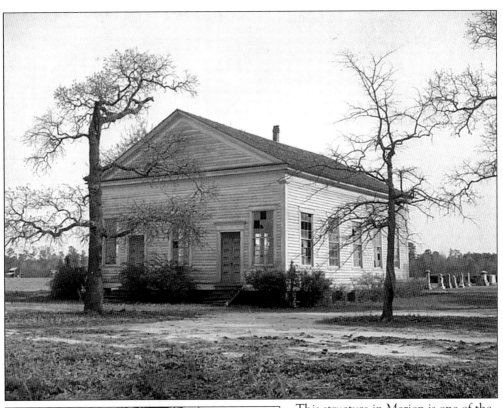

This structure in Marion is one of the oldest Methodist churches in South. The photograph was taken in 1953.

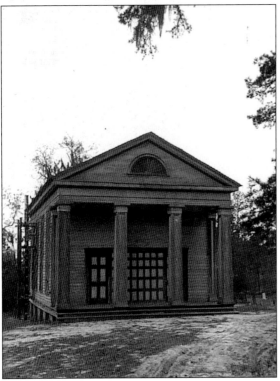

Shown here is High Hills Baptist Church in Stateburg. The church, built during the 1780s, was located on land granted by Gen. Thomas Sumter.

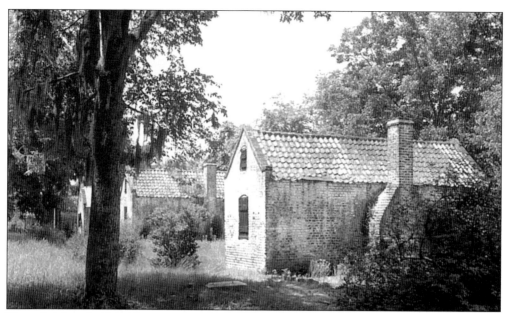

These brick and terra cotta structures housed slaves in 19th-century Charleston. This picture was taken in 1940.

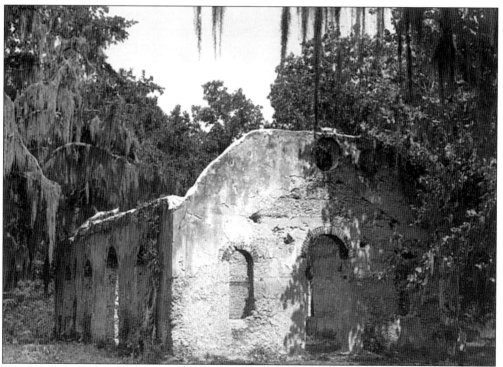

These are the ruins of the Chapel of Ease of St. Helena's Church in Beaufort. The chapel, originally built in 1740, became a separate church after the Revolutionary War. The chapel interior was destroyed by a forest fire in 1886, but its tabby walls survived. Tabby is a material similar to concrete, composed of oyster shells, sand, and lime, then finished with stucco and plaster. The word is derived from the Spanish "tapia," which means mud wall.

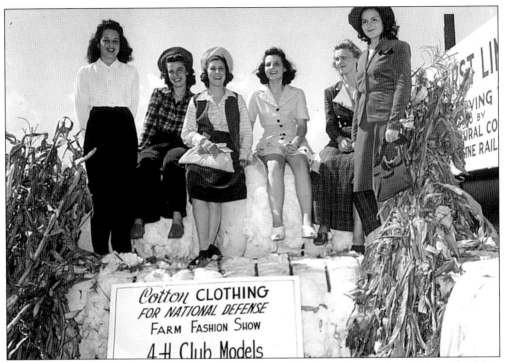

The Better Farm Living train traveled throughout the state during the 1940s and 1950s, bringing the latest agricultural technology to farmers. In 1941, the train began its journey in Columbia. This photo shows a fashion show that marked the opening.

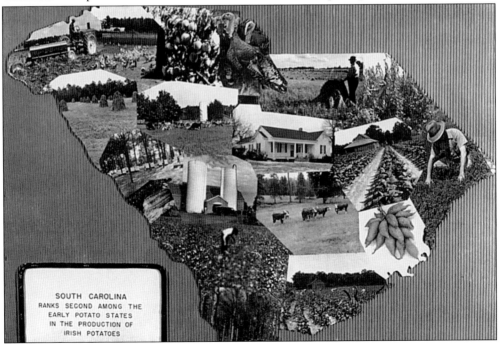

This 1947 pictorial agricultural map of South Carolina illustrated the diverse range of agricultural products.

INDEX